IMAGINARY ANIMALS

Chevaux de
courses
(Race Horses)
Edgar Degas,
about
1895–1900

IMAGINARY ANIMALS

POETRY AND ART FOR YOUNG PEOPLE
edited by Charles Sullivan

At Grass
Philip Larkin (1922–1985)

The eye can hardly pick them out
From the cold shade they shelter in,
Till wind distresses tail and mane;
Then one crops grass, and moves about
—The other seeming to look on—
And stands anonymous again.

Yet fifteen years ago, perhaps
Two dozen distances sufficed
To fable them: faint afternoons
Of Cups and Stakes and Handicaps,
Whereby their names were artificed
To inlay faded, classic Junes—

Silks at the start: against the sky
Numbers and parasols: outside,
Squadrons of empty cars, and heat,
And littered grass: then the long cry
Hanging unhushed till it subside
To stop-press columns on the street.

Do memories plague their ears like flies?
They shake their heads. Dusk brims the shadows.
Summer by summer all stole away,
The starting-gates, the crowds and cries—
All but the unmolesting meadows.
Almanacked, their names live; they

Have slipped their names, and stand at ease,
Or gallop for what must be joy,
And not a fieldglass sees them home,
Or curious stop-watch prophesies:
Only the groom, and the groom's boy,
With bridles in the evening come.

Harry N. Abrams, Inc., Publishers

This book is dedicated to the memories of

Valerie Worth Bahlke (1933–1994)

Dorothy Robinson Kidder (1917–1995)

Charlotte Kidder Ramsay (1941–1995)

three dear friends who loved

children, animals,

and the wonders of imagination

*A portion of the proceeds from the sale of this book will be
contributed to The American Foundation for the Arts*

Editor: Elisa Urbanelli
Designers: Dirk Luykx, Arlene Lee
Photo Editor: Lauren Boucher
Text Permissions: Roxana Marcoci

Library of Congress Cataloging-in-Publication Data
Imaginary animals : poetry and art for young people / edited by
Charles Sullivan
p. cm.
Includes index.
Summary: Introduces poetry and art through the themes of animals
and beasts in this selection of over eighty poems juxtaposed with
illustrations.
ISBN 0–8109–3470–1 (clothbound)
1. Children's poetry. 2. Young adult poetry. 3. Animals—
Juvenile poetry. 4. Animals—Pictorial works—Juvenile literature.
5. Art appreciation. [1. Poetry—Collections. 2. Animals—Poetry.
3. Art appreciation.] I. Sullivan, Charles, 1933– .
PN6109.97.I46 1996
808.81'936—dc20 96–11526

Published in 1996 by Harry N. Abrams, Incorporated, New York
A Times Mirror Company

Printed and bound in Singapore

To the Reader

My first imaginary animals were the horses on which I and my friends went galloping when we played cowboys and cowgirls, Robin Hood, King Arthur, and other fast-moving games in the wide open spaces of childhood. We knew about "real" horses, of course, and ponies, as well as rocking horses, merry-go-rounds, and other make-believe creatures made by grown-ups. But nothing was easier or better than creating our own—small, fast, tireless horses with names like "Silver" and "Scout" and "Blackie." Clippety-clopping along on them, we chased after cattle, or dragons, or hard-riding enemies who turned out to be friends. Sometimes they chased us instead. Have you ever played games like that?

I forgot about those games as I grew up. But later I came to realize that children aren't the only ones who frequently imagine animals and other things. In my teens I discovered poetry—for example, James Dickey's "A Birth":

> Inventing a story with grass,
> I find a young horse deep inside it.
> I cannot nail wires around him;
> My fence posts fail to be solid . . .

Can you see grass? The horse? Do you understand why the fence is harder to see—because this (imaginary) horse wants to be free?

Poets from the earliest times have written about animals of different kinds—not just horses, but also cats and dogs and foxes, hares and bears and wolves, monsters of the earth and sea and sky, and also some really mysterious, scary creatures, such as "things that go bump in the night," so vaguely described that we, the readers, do most of the imagining about them. But even the least frightening animals could not exist if we did not imagine them. Gelett Burgess created this one in just four lines:

> I never saw a purple cow,
> I never hope to see one,
> But I can tell you anyhow
> I'd rather see than be one.

The amusing twist in his poem is that we *can* see a purple cow (we can imagine it) almost as soon as we read or hear the poet's words. Or we can see a shiny green cow, or a blue one with yellow polka dots, or any other kind of cow we wish to see. Imagination takes us beyond the limits of what is "real" or "true." Emily Dickinson (who never actually saw the great prairies of the American West) wrote this about the power of revery, or daydreaming:

> To make a prairie it takes a clover
> and one bee,—
> One clover, and a bee,
> And revery.
> The revery alone will do
> If bees are few.

As I grew up I found that artists, too, have always been interested in animals, real and imaginary. The very earliest paintings, found in caves in France and Spain, are pictures of shaggy mammoths (like huge elephants), saber-toothed tigers, and other terrifying creatures that used to roam the earth. Why were these paintings made, thousands of years ago? For children, I think—for helping children (safe at home) to imagine what might be out there in the world beyond the cave—for teaching them which animals to hunt and how to do it, which ones to avoid and how to get away. Why do we not see cave paintings of anything other than large animals? Because no other things (trees, flowers, mountains, rivers, or stars) were nearly so important for survival in early times.

This book is something like one of those ancient caves. It contains all sorts of pictures, old and new, as well as stories told by poets. In it, I hope you will find out more about animals—safe ones, dangerous ones, strange ones, and familiar ones. You may not learn how to hunt a prehistoric mammoth, but you will explore the best places to see deer, with Philip Booth:

> Forget roadside crossings.
> Go nowhere with guns.
> Go elsewhere your own way,
>
> lonely and wanting. Or
> stay and be early:
> next to deep woods
>
> inhabit old orchards....

With the help of poets, painters, photographers, sculptors, and other artists, you will see the hairy creature known as Bigfoot in the Northwest, the Loch Ness monster in Scotland, and the fierce dragon killed by Saint George. You will hear a woman talking with cats, a man speaking to fish, and a fish answering back. You will discover how it feels to be a frisky lion cub, a very musical bird, a dancing lobster, an elephant that eats ice cream, or an alligator that likes candied sweet potatoes. Can you imagine them?

Several years ago, while I was looking at a picture of old boats that people used to live on, I wondered what it would be like for me. Almost immediately, I started writing:

> My house is a boat,
> my boat is a house,
> I live on the river
> with Morris the mouse....

Morris is an imaginary animal, but he seems very real to me and to many of the children (and grown-ups) who first encountered him in my earlier book, *Imaginary Gardens*. Therefore I am including the poem "Houseboat Mouse" in this book, too. And I know that Morris wants to have further adventures, so I have turned my imagination loose in two new poems about him: "Morris Goes to the Art Museum" and "Morris & Boris." I hope you enjoy them.

As before, I will ask a favor of you. Please write and tell me how you like this book. Even if you don't like some of it (or all of it) I am interested in your opinions. Here's my name and address.

Charles Sullivan
P.O. Box 6717
McLean, Virginia 22106-6717

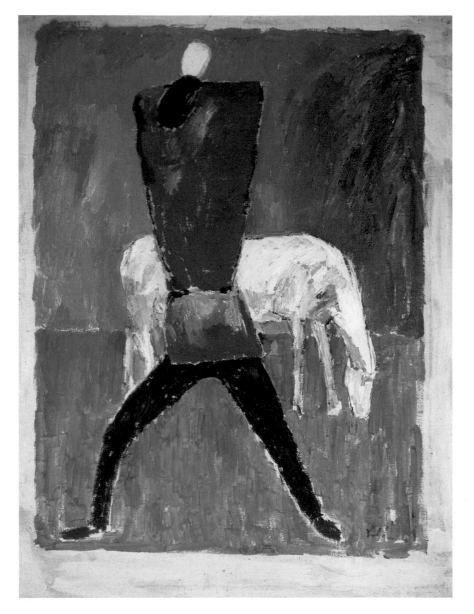

Man and Horse
Kasimir Malevich,
1933

A Birth

James Dickey (born 1923)

Inventing a story with grass,
I find a young horse deep inside it.
I cannot nail wires around him;
My fence posts fail to be solid,

And he is free, strangely, without me.
With his head still browsing the greenness,
He walks slowly out of the pasture
To enter the sun of his story.

My mind freed of its own creature,
I find myself deep in my life
In a room with my child and my mother,
When I feel the sun climbing my shoulder

Change, to include a new horse.

The Ride
Richard Wilbur (born 1921)

The horse beneath me seemed
To know what course to steer
Through the horror of snow I dreamed,
And so I had no fear,

Nor was I chilled to death
By the wind's white shudders, thanks
To the veils of his patient breath
And the mist of sweat from his flanks.

It seemed that all night through,
Within my hand no rein
And nothing in my view
But the pillar of his mane,

I rode with magic ease
At a quick, unstumbling trot
Through shattering vacancies
On into what was not,

Till the weave of the storm grew thin,
With a threading of cedar-smoke,
And the ice-blind pane of an inn
Shimmered, and I awoke.

How shall I now get back
To the inn-yard where he stands,
Burdened with every lack,
And waken the stable-hands

To give him, before I think
That there was no horse at all,
Some hay, some water to drink,
A blanket and a stall?

The Poet Reclining
Marc Chagall, 1915

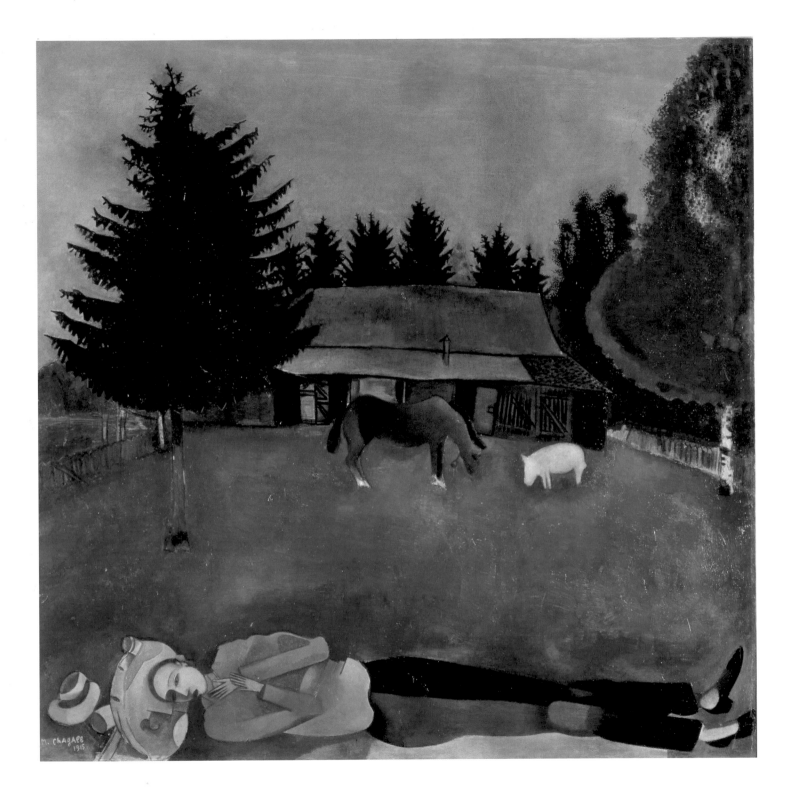

Horse and Tree

Rita Dove (born 1952)

Everybody who's anybody longs to be a tree—
or ride one, hair blown to froth.
That's why horses were invented, and saddles
tooled with singular stars.

This is why we braid their harsh manes
as if they were children, why children
might fear a carousel at first for the way
it insists that life is round. No,

we reply, there is music and then it stops;
the beautiful is always rising and falling.
We call and the children sing back *one more time*.
In the tree the luminous sap ascends.

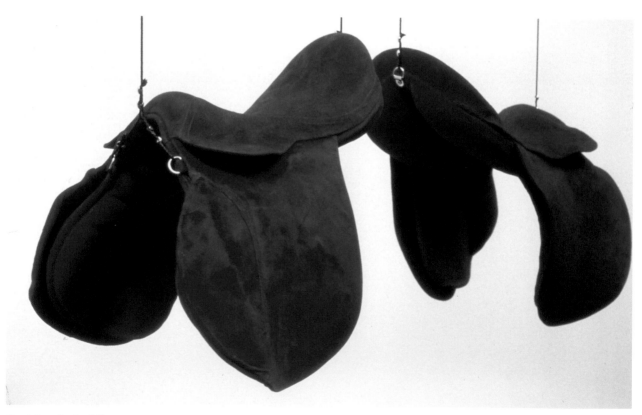

Red Suede Saddles
Julia Kunin, 1993

The Poem
Donald Hall (born 1928)

It discovers by night
what the day hid from it.
Sometimes it turns itself
into an animal.
In summer it takes long walks
by itself where meadows
fold back from ditches.
Once it stood still
in a quiet row of machines.
Who knows
what it is thinking?

To Make a Prairie
Emily Dickinson (1830–1886)

To make a prairie it takes a clover and one bee,
One clover, and a bee,
And reverie.
The reverie alone will do,
If bees are few.

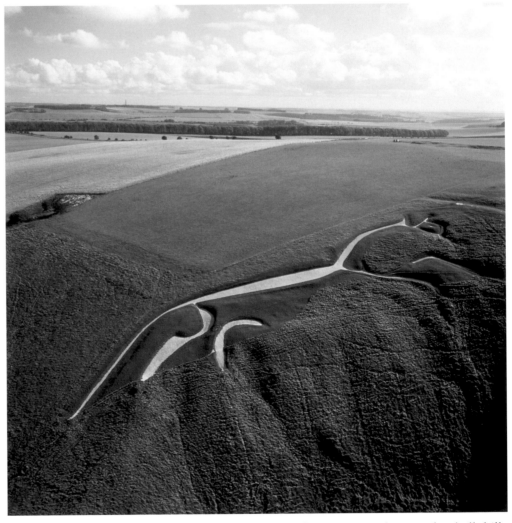

An imaginary horse, 360 feet long, was carved by Celtic artists on the top of a chalk hill in Uffington, Oxfordshire, England, possibly as early as 1000 B.C. The purpose of this gigantic carving is unknown.

The People of Troy Drag the Horse Inside

from The Aeneid, *Book II (234–249)*

Virgil (70–19 B.C.)

translated from Latin by John Dryden

A spacious breach is made, the town lies bare.
Some hoisting levers, some the wheels prepare
And fasten to the horse's feet; the rest
With cables haul along the unwieldy beast;
Each on his fellow for assistance calls.
At length the fatal fabric mounts the walls,
Big with destruction. Boys, with chaplets crowned,
And choirs of virgins sing and dance around.
Thus raised aloft and then descending down,
It enters o'er our heads and threats the town.
O sacred city, built by hands divine!
O valiant heroes of the Trojan line!
Four times he stuck, as oft the clashing sound
Of arms was heard, and inward groans rebound.
Yet mad with zeal and blinded with our fate,
We haul along the horse in solemn state,
Then place the dire portent within the tower.
Cassandra cried and cursed the unhappy hour,
Foretold our fate, but by the god's decree
All heard and none believed the prophecy.
With branches we the fanes adorn, and waste
In jollity the day ordained to be our last.

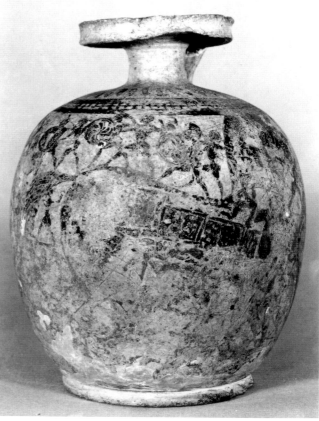

Trojan Horse Vase
Greece, 6th century B.C.

According to ancient legends, the Greeks
pretended to break off their attack on Troy,
leaving a huge wooden horse behind. Hollow,
it was full of Greek soldiers. The unsuspecting
Trojans dragged it inside their fortress, not
realizing they had been tricked until they were
taken by surprise that night.

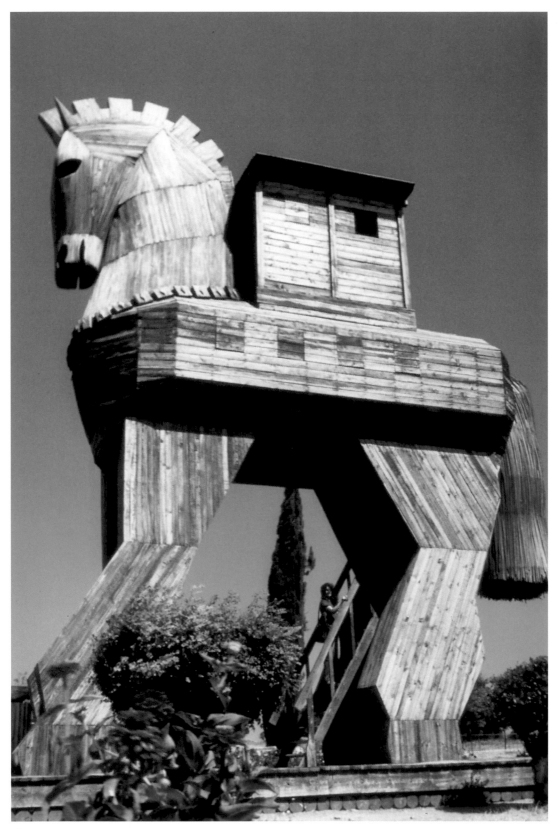

Tourists visiting the ruins of Troy (modern Hissarlik) in Turkey today can get inside this recent replica of the famous Trojan Horse, whose name is still synonymous with deception.

A Handsome Centaur

from The Metamorphoses, *Book XII (392–400)*
Ovid (43 B.C.–17 A.D.?)
translated from Latin by Allen Mandelbaum

His golden beard had just begun to grow;
his hair was golden, even as it flowed
over his shoulders to his equine chest.
His face had features strong and eloquent;
his neck, his hands, his manly chest could match
the finest statues—just as did the rest
of all his human parts. But, too, below,
the grace the centaur's equine features showed
was flawless.

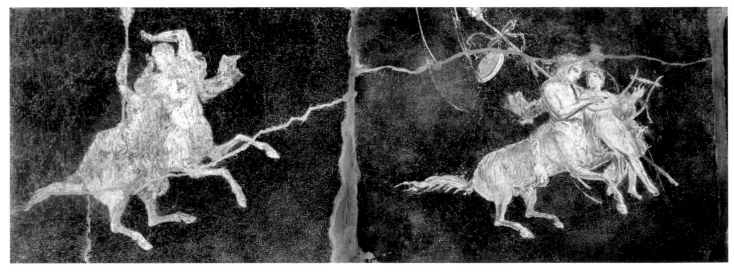

Fresco of Centaur
Herculaneum, about A.D. 70

A centaur (half man, half horse in Greek
mythology) teaches a young man to play the
lyre, a small harp used to accompany songs
or poems.

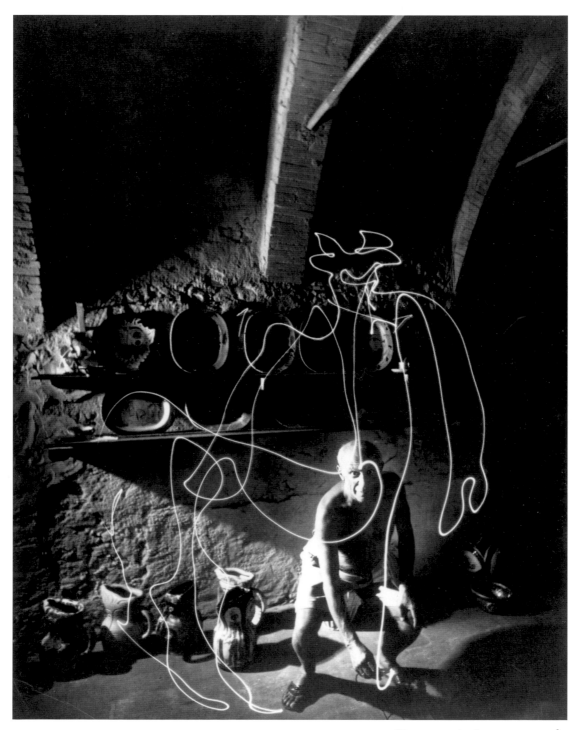

Picasso painting a centaur by
flashlight, Vallauris, France
Gjon Mili, 1949

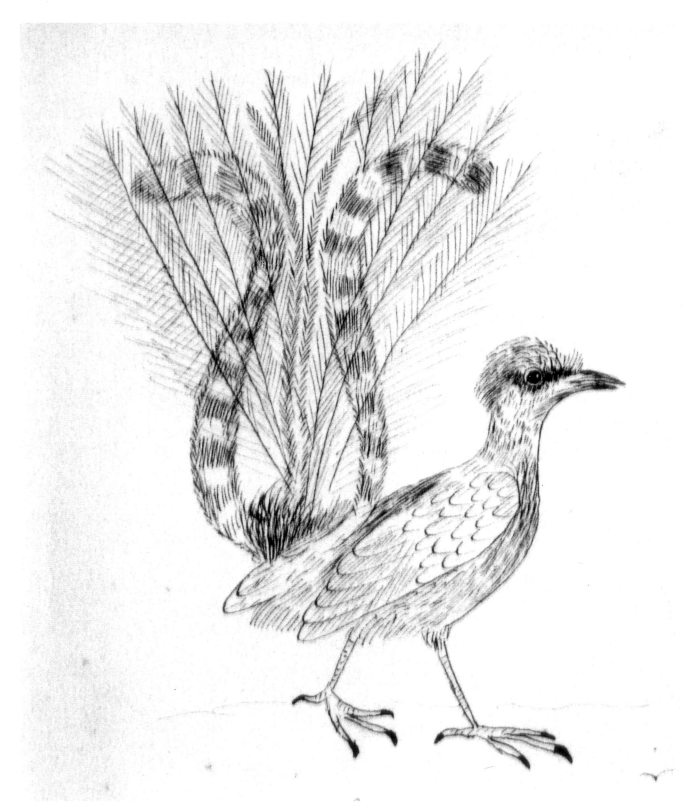

Lyre-Bird, detail from *Carnet Animalier*
Eva Gonzalès, 1879

Hard to imagine? Birds like this actually exist in Australia today.

Once Upon a Time in School

Jacques Prévert (1900–1977)

translated from French by Charles Sullivan

2 + 2 = 4

4 + 4 = 8

8 + 8 = 16

Repeat! says the teacher.

Two plus two equals four,
four plus four equals eight,
eight plus eight equals sixteen.

But there's a lyre-bird
flying by—
the child sees it,
the child hears it,
the child calls to it:
Save me,
play with me,
bird!

So the bird comes down
and plays with the child.
Two plus two equals four.
Repeat! says the teacher,
and the child plays,
the bird plays with him.

Four plus four equals eight,
eight plus eight equals sixteen,
and what do sixteen plus sixteen equal?
Sixteen plus sixteen don't equal anything,
and especially not thirty-two
in any case,
and away they go.

And the child has hidden the bird
in his desk,
and all the children
hear its song
and all the children
hear the music,
and eight plus eight go away in their turn
and four plus four and two plus two
in their turn take off,
and one plus one don't equal either one or two,
one flies away with one the same way.
And the lyre-bird plays
and the child sings,
and the teacher yells at the child:
When are you going to stop this nonsense?

But all the other children
listen to the music
and the walls of the schoolroom
collapse peacefully.
And the windows turn back into sand,
and ink becomes water again,
and desks are becoming trees,
and chalk returns to the white cliff,
the feathered writing-quill is once again
a bird.

A Lesson in Handwriting

Alastair Reid (born 1926)

Try first this figure 2,
how, from the point of the pen,
clockwise it unwinds itself
downward to the line,
making itself a pedestal to stand on.
Watch now. Before your eyes it becomes a swan
drifting across the page, its neck so carefully
poised, its inky eye
lowered in modesty.
As you continue, soon,
between the thin blue lines,
swan after swan sails beautifully past you,
margin to margin, 2 by 2 by 2—
a handwritten swirl of swans.
Under them now unroll
the soft, curled pillows of the 6's,
the acrobatic 3's, the angular 7's,
the hourglass 8's, and the neat tadpole 9's,
each passing in review
on stilts or wheels or platforms
in copybook order.
Turn the page, for now
comes the alphabet, an eccentric
parade of odd characters. If at first you tangle,
now and again, in a loop or a twirl,
no matter. Each in time will dawn
as faces and animals do, familiar,
laughable, crooked, quirky.
Begin with the letter S. Already
it twists away from the pen like a snake or a
watch spring,
coiled up and back to strike. SSSS, it says,
hissing and slithering off into the ferns of the F's.
Follows a line of stately Q's floating
just off the ground, tethered by their tails,
over the folded arms of the W's
and the akimbo M's. Open-eyed, the O's
roll after them like bubbles blown away.
Feel how the point curls round them lovingly
after the serious three-tongued E's.

See now how the page fills up
with all the furniture of writing—the armchair H's,
the ladders and trestles of A's and Y's and X's,
the T-shaped tables and the upholstered B's.
The pen abandons a whole scaffolding
of struts and braces, springs and balances,
on which will rest eventually
the weight of a written world, storey on storey
of words and vows, all the long-drawn-out telling
that pens become repositories of.
These are now your care, and you may give them
whatever slant or human twist you wish
if it should please you. But you will not alter
their scrawled authority, durable
as stone, silent, grave, oblivious
of all you make them tell.

Tomorrow, words begin.

Marc Chagall standing in front of
The Triumph of Music, a painting
he created for Lincoln Center in
New York, 1965–66

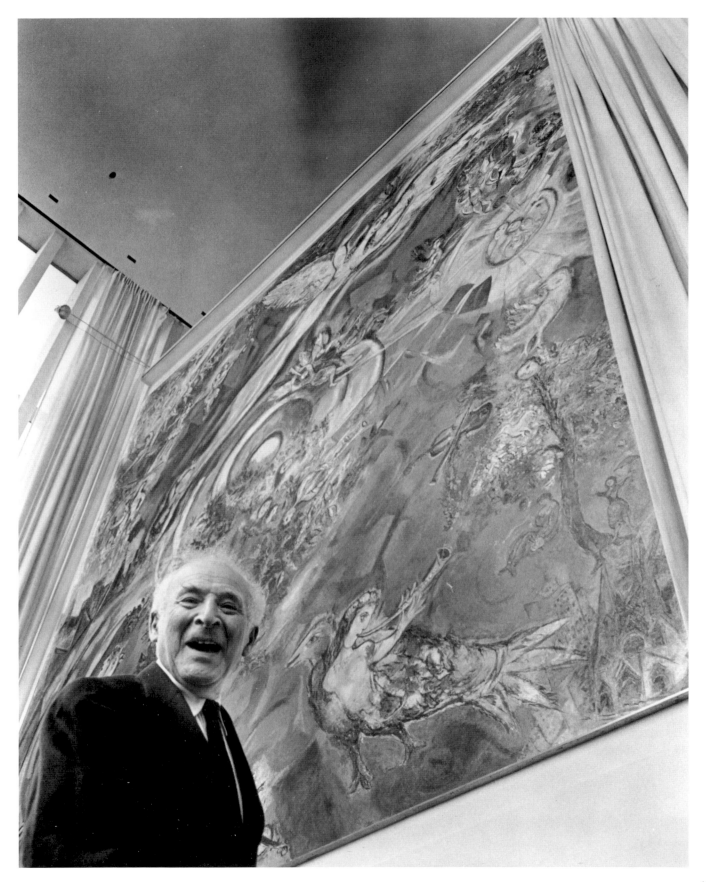

The Crow

Barbara Angell (1930–1990)

Someone has turned into a crow.
It flies to the top of a bare tree,
folds its wings like a cloak.

Maybe I am the crow,
or is it another person?
It is skimming through the air making a story.

I float over the field,
scuffling the tops of weeds,
find myself standing in the dead grass

as I step into my body,
neat, featherless,
heavy.

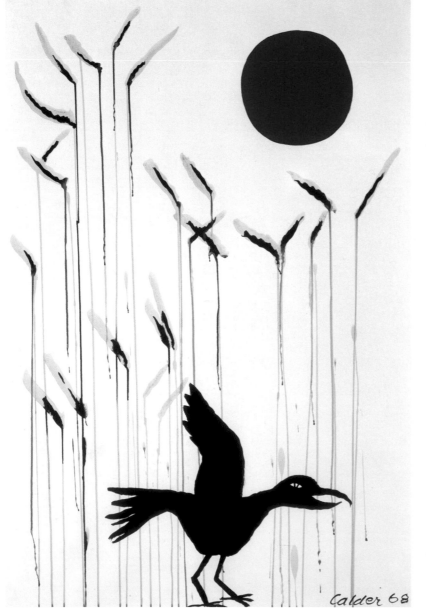

Cattails and Bird
Alexander Calder, 1968

Morning of the Rooster
Romare Bearden, 1980

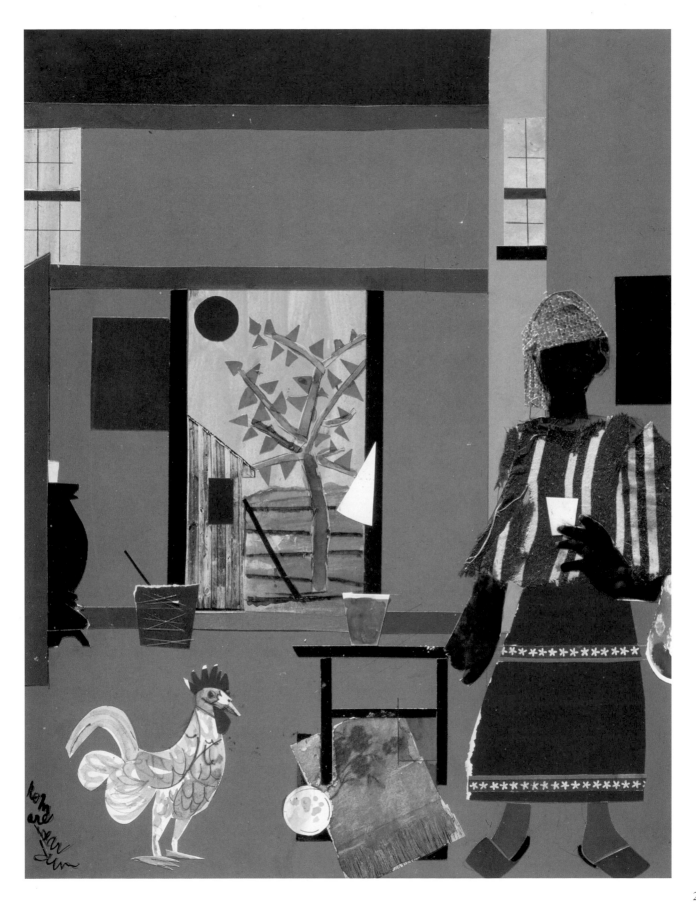

Sometimes I Think I'd Rather Crow

Anonymous

Sometimes I think I'd rather crow
and be a rooster than just roost
and be a crow, but I don't know.

A rooster he can roost also,
which isn't fair when crows can't crow,
but life's not always fair, you know?

Crows are glad of one thing, though—
nobody likes to be eating crow,
while roosters may taste good enough
for anyone, unless they're tough.

Once I heard a rooster win a bet
by crowing half of the alphabet,
but the crows I know can only caw—
if they tried to crow the other half,
the noise would surely make you laugh!

New Animals

Donald Hall (born 1928)

Walking one morning
we cannot find
Kate or Wesley,
or his cows and sheep,
or the hens she looks
after. In my dreams
we spend all morning
looking for their old
bodies in tall grass
beside barn
and henyard. Finally
we discover them,
marching up the dirt
road from Andover—
excited, laughing, waving
to catch our attention
as they shepherd
new animals
home to the farm.
They traded Holsteins
and Rhode Island Reds
for zebras, giraffes,
apes, and tigers. They lead
their parade back
to the barn, and the sheep-
dog ostrich
nips at the errant
elephant's heels
and goads the gaudy
heroic lions
and peacocks that keen
AIEE AIEE.

Patterns for "Bird of Paradise" quilt top
Artist unknown, vicinity of Albany,
New York, 1853–63

The Toomai of Elephants
Rudyard Kipling (1865–1936)

I will remember what I was. I am sick of rope and chain—
 I will remember my old strength and all my
 forest-affairs.
I will not sell my back to man for a bundle of
 sugar-cane.
 I will go out to my own kind, and the wood-folk in
 their lairs.

I will go out until the day, until the morning break,
 Out to the winds' untainted kiss, the waters' clean
 caress.
I will forget my ankle-ring and snap my picket-stake.
 I will revisit my lost loves, and playmates
 masterless!

The Frog He Did A-Courting Go

Folk Song

The frog he did a-courting go
through summer heat and winter snow,
to see the prettiest girl in town,
but she would have none of him, of him,
she would have none of him.

Then he wrote her a letter and even better
he left a valentine card in her yard,
with a big green heart and the words "ock-kungh,"
but she would have none of him, of him,
she would have none of him.

Then he tried to use the telephone,
but all he got was a dial tone,
so she never heard "ock-kungh, ock-kungh,"
when he spoke to her of his love, his love
when he spoke to her of his love.

Then he fell asleep, sitting all alone,
and dreamed he turned into an ice-cream cone
to please the prettiest girl in town,
but she would have none of him, of him,
she would have none of him.

Sophie Emmerson holding a ceramic frog
ice-cream cone by David Gilhooly
Shirley Ross Davis, 1995

Imaginary Animals

Charles Sullivan (born 1933)

When I go out
and about in the world,
with people and animals too,
I never meet Christopher Robin—
do you?
I never see Winnie-the-Pooh.

But when I come back
from wherever I've been,
and sit in my comfortable chair,
I remember the child I pretended to be
and I talk with my favorite bear.

"What's happening, Pooh?" I say to him.
"Did you have a good day?" say I.

"A dragon flew out of a book," he says,
"and took our new honey supply."

"Are you sure it wasn't a bee?" I ask.

"Quite sure," is his reply.
"Because it didn't buzz, you see . . .
it was more like a dragonfly—
it had big shiny wings
and . . . feelers and things
and a scary yellow eye!"

"And it couldn't have been a bear," I say,
'cause bears don't know how to fly."

"I do," says Pooh. "In fact I just flew
straight after whatever it was—
out of the window, or maybe the door,
and over the roof of the bicycle store,
and right across town
with the rain coming down—
oh, you should have seen me go!"

"And then?" I ask.

"And then I turned around," says he,
"when it suddenly entered a hollow tree,
and all of the other bears—the bees—
—the dragonflies, I mean—
came chasing after me."

"My dear old Pooh," I say to him,
"is the honey entirely gone,
or do we have a drop or two?
I brought some special biscuits home
for you and me to put it on."

"I think I saved a little bit
the dragonfly forgot," says Pooh.
"There's just enough to share with you,
enough for me and you."

Tonight we sit together
in our very easy chairs,
and spread the biscuits on a plate—
one for me and two for Pooh,
and two for me and one for him—
but we don't eat them yet, we wait
until the kettle is as hot as it can get,
then make the tea in our blue pot
and warm the jar of honey
on the side.

To me the honey jar seems full,
but Pooh must have his dreams.

"That swarm of dragonflies," says he.
"I tried to be brave like you,
when I was chasing one,
but with a hundred chasing me
I did get scared . . . I cried."

"You're very brave," I say to Pooh,
"you're just as brave as I would be
if I had dragons chasing me,
or dragonflies, or bees, or bears . . .
or any kind of monsters
that came creeping
up the stairs."

"You're right," says Pooh.
"If that's how brave you are,
I'm really just as brave as you,
but I could still be frightened
by these stories late at night—
so let's not have things creeping
up or down the stairs
or anywhere—
I'm tired now,
I should be sleeping."

And I agree.
The story ends
with one more rhyme
when it's sleepy time
for my friend Pooh—
or me—or you.

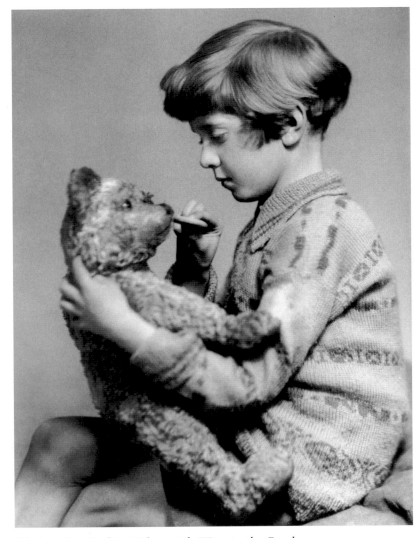

Christopher Robin Milne with Winnie-the-Pooh
Marcus Adams, March 1928

27

Saint George and the Dragon

from The Faerie Queen, *First Book, Canto XI*
Edmund Spenser (1552–1599)

The knight with that old dragon fights
Two days incessantly;
The third him overthrows, and gains
Most glorious victory.

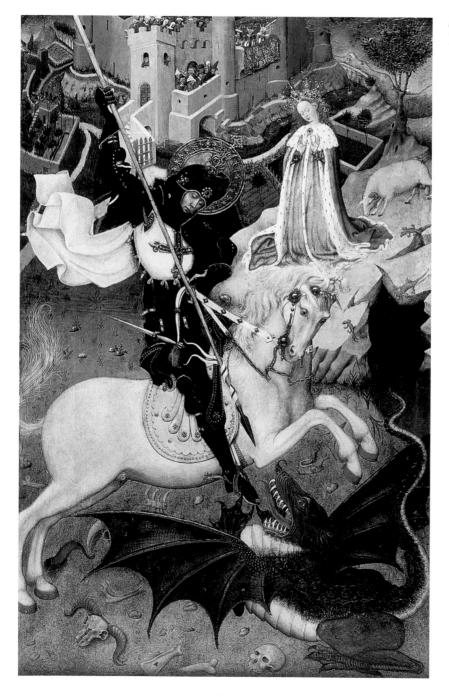

Saint George Killing the Dragon
Bernardo Martorell, 1430–35

The Big Baboon Was There

from Animal Fair
Anonymous

I went to the animal fair,
The birds and beasts were there.
The big baboon by the light of the moon
Was combing his auburn hair.

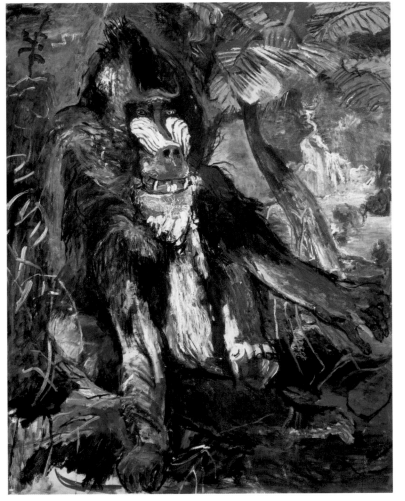

Mandrill
Oskar Kokoschka, 1926

A mandrill is a large, fierce, gregarious
baboon found in western Africa.

Dragons Are Too Seldom
Ogden Nash (1902–1971)

To actually see an actual marine monster
Is one of the things that I do before I die I wonster.
Should you ask me if I desire to meet the bashful
 inhabitant of Loch Ness,

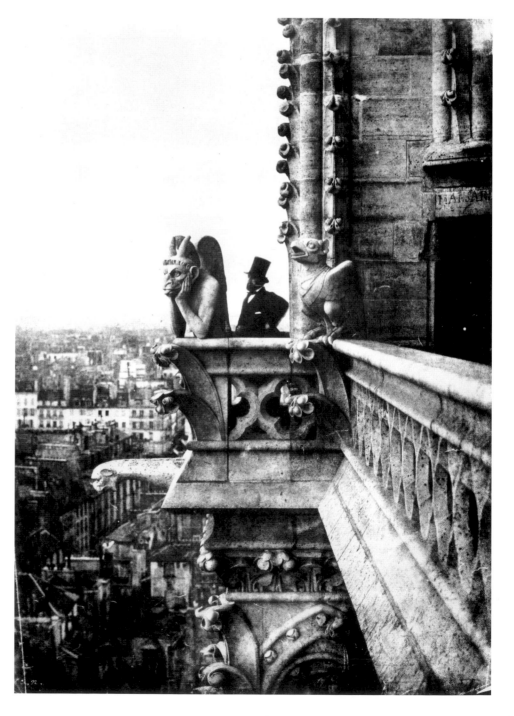

*Henri le Secq and
Gargoyles of Notre-Dame*
Charles Negre, 1851

In his search for dragons
and such, poet Nash
includes almost everything
from millionaires to sea
monsters, but he leaves out
scary-looking gargoyles
(actually rainspouts)
like these, on a
cathedral in Paris.

I could only say yes.
Often my eye with moisture dims
When I think that it has never been my good fortune to
 gaze on one of Nature's whims.
Far from ever having seen a Gorgon
I haven't even seen the midget that sat in the lap of Mr.
 Morgan.
Indeed it is my further ill fortune or mishap
That far from having seen the midget that sat in it I have
 never even seen Mr. Morgan's lap.
Indeed I never much thought about Mr. Morgan's hav-
 ing a lap because just the way you go into churches
 and notice the stained glass more than the apses
When you think about multi-millionaires you don't think
 about their laps as much as their lapses;
But it seems that they do have laps which is one human
 touch that brings them a little closer to me and you,
And maybe they even go so far as to sometimes have
 hiccups too.
But regular monsters like sea serpents don't have laps or
 hiccups or any other characteristic that is human,
And I would rather see a second-rate monster such as a
 mermaid than a first-rate genius such as John
 Bunyan or Schiaparelli or Schubert or Schumann;
Yes, I would rather see one of the sirens
Than two Lord Byrons,
And if I knew that when I got there I could see Cyclops
 or Scylla and Charybdis or Pegasus
I would willingly walk on my hands from here to Dallas,
 Tegasus,
Because I don't mean to be satirical,
But where there's a monster there's a miracle,
And after a thorough study of current affairs, I have
 concluded with regret
That the world can profitably use all the miracles it can
 get,
And I think life would be a lot less demoralizing,
If instead of sitting around in front of the radio listening
 to torture singers sing torture songs we sat around
 listening to the Lorelei loreleising.

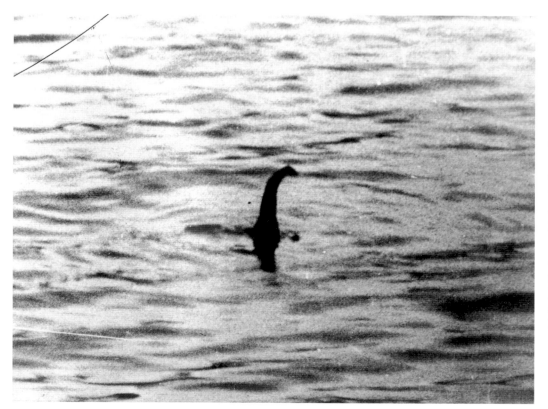

Supposedly a photograph of "Nessie," the legendary monster, swimming in its home waters, Loch Ness, Scotland
R. K. Wilson, 1934

Some people believe that strange creatures have lived in this large lake since prehistoric times; others think it's impossible.

Nessie

Claudia Ramsay (born 1936)

Far and away, in a hidden recess,
lives the fabulous monster of Scotland's Loch Ness.

Up there in the highlands, far from my home,
old Nessie dives deep, swims fast, and alone.

Some say she's been there for eons of time,
others say no—she's a story, a rhyme.

Scotland's so far, and Loch Ness so deep,
I may never see her, except in my sleep,

as she arches her neck, getting set for a dive,
as she shows that a monster might still be alive.

Things That Go Bump in the Night

(Scottish Prayer)

As recited by Anne Faith Donaldson

From ghoulies and ghosties
and long-leggety beasties,
and things that go bump in night,
let the Good Lord deliver us.

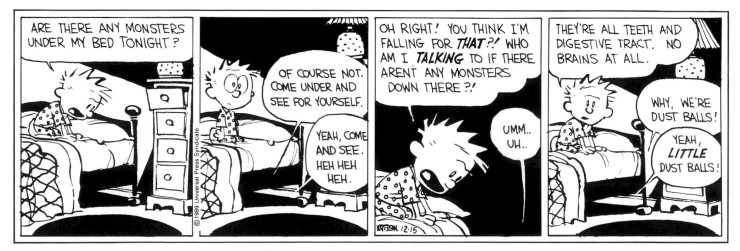

"Are There Any Monsters Under My Bed Tonight?"
Calvin and Hobbes
Bill Watterson, © 1989

Vesper

Alcman (7th century B.C.)

translated from Greek by F. L. Lucas

Now sleep the mountain-summits, sleep the glens,
The peaks, the torrent-beds; all things that creep
On the dark earth lie resting in their dens;
Quiet are the mountain-creatures, quiet the bees,
The monsters hidden in the purple seas;
And birds, the swift of wing,
Sit slumbering.

Lullaby of a Woman of the Mountains

Padraic Pearse (1879–1916)

House, be still, and ye little grey mice,
Lie close tonight in your hidden lairs.

Moths on the window, fold your wings,
Little black chafers, silence your humming.

Plover and curlew, fly not over my house,
Do not speak, wild barnacle, passing over the mountain.

Things of the mountain that wake in the night-time,
Do not stir tonight till the daylight whitens!

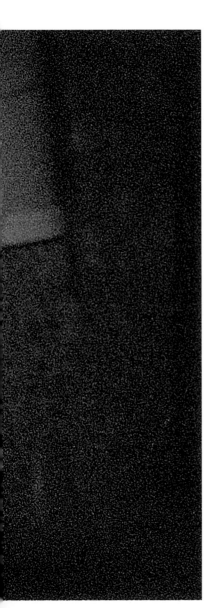

A New Zealand Brushtail Possum in the Dark
Dr. Graham Hickling, 1992

Bête Noir

Cajun poem

big old trouble follows me
half a ton at least

if I can't run away from it
I'll learn to leash the beast

Man and Large Dog
Bill Traylor, 1939–42

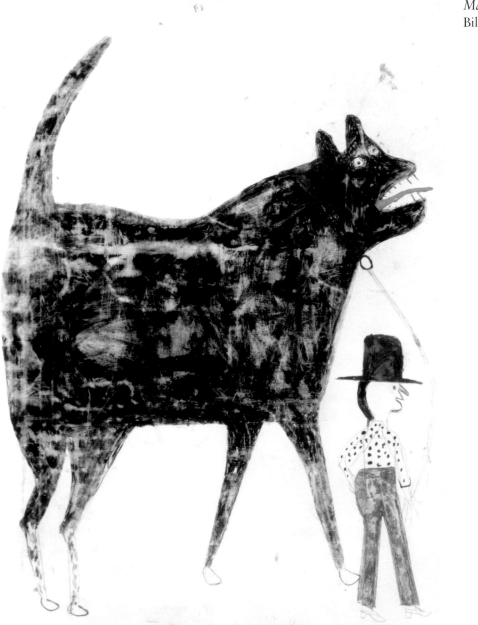

Le Chien (The Dog)
Alberto Giacometti, 1951

Bony
Simon J. Ortiz (born 1941)

My father brought that dog
home
in a gunny sack.
The reason we called it Bony
was because it was skin and
bones.

It was a congenital problem
or something that went way
back
into its dog's history.

We loved it without question,
its history and ours.

Alexander

from Sophisticated Alligators
Noël Miller (born 1940)

A lexander Alligator
Ordered candied sweet potater.
When the man was slow to cater,
Alexander ate the waiter.

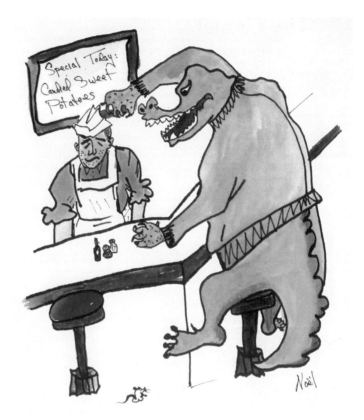

*Alexander the Alligator at
a Lunch Counter*
Noël Miller, 1995

Humming-Bird

D. H. Lawrence (1885–1930)

I *can* imagine, in some otherworld
Primeval-dumb, far back
In that most awful stillness, that only gasped and
 hummed,
Humming-birds raced down the avenues.

Before anything had a soul,
While life was a heave of Matter, half inanimate,
This little bit chipped off in brilliance
And went whizzing through the slow, vast, succulent
 stems.

I believe there were no flowers then,
In the world where the humming-bird flashed ahead of
 creation.
I believe he pierced the slow vegetable veins with his
 long beak.
Probably he was big
As mosses, and little lizards, they say, were once big.
Probably he was a jabbing, terrifying monster.

We look at him through the wrong end of the long
 telescope of Time,
Luckily for us.

The Camel

Carmen Bernas de Gasztold

translated from French by Rumer Godden

Lord,
do not be displeased.
There *is* something to be said for pride
against thirst, mirages,
and sandstorms;
and I must say
that, to face and rise above
these arid desert dramas,
two humps
are not too many,
nor an arrogant lip.
Some people criticize
my four flat feet,
the bases of my pile of joints,
but what should I do
with high heels
crossing so much country,
such shifting dreams,
while upholding my dignity?
My heart wrung
by the cries of jackals and hyenas,
by the burning silence,
the magnitude of Your cold stars,
I give you thanks, Lord,
for this my realm,
wide as my longings
and the passage of my steps.
Carrying my royalty
in the aristocratic curve of my neck
from oasis to oasis,
one day shall I find again
the caravan of the magi?
And the gates of Your paradise?

Amen

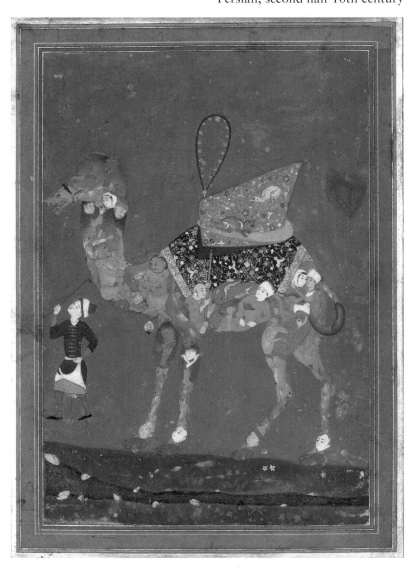

Composite Camel with Groom
Persian, second half 16th century

The Second Coming
W. B. Yeats (1865–1939)

Turning and turning in the widening gyre
The falcon cannot hear the falconer;
Things fall apart; the centre cannot hold;
Mere anarchy is loosed upon the world,
The blood-dimmed tide is loosed, and everywhere
The ceremony of innocence is drowned;
The best lack all conviction, while the worst
Are full of passionate intensity.

Surely some revelation is at hand;
Surely the Second Coming is at hand.
The Second Coming! Hardly are those words out
When a vast image out of *Spiritus Mundi*
Troubles my sight: somewhere in sands of the desert
A shape with lion body and the head of a man,
A gaze blank and pitiless as the sun,
Is moving its slow thighs, while all about it
Reel shadows of the indignant desert birds.
The darkness drops again; but now I know
That twenty centuries of stony sleep
Were vexed to nightmare by a rocking cradle,
And what rough beast, its hour come round at last,
Slouches towards Bethlehem to be born?

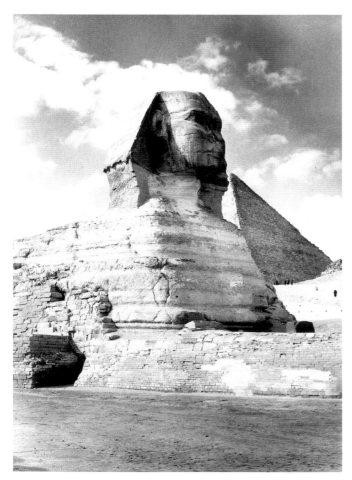

The Great Sphinx, Giza, Egypt
about 2570–2544 B.C.

A mythical creature, sometimes depicted with the
head of a man and the body of a lion, the sphinx
shown here is one of Egypt's oldest and most
mysterious works of art.

wild(at our first)beasts uttered human words

e. e. cummings (1894–1962)

Wild(at our first)beasts uttered human words
—our second coming made stones sing like birds—
but o the starhushed silence which our third's

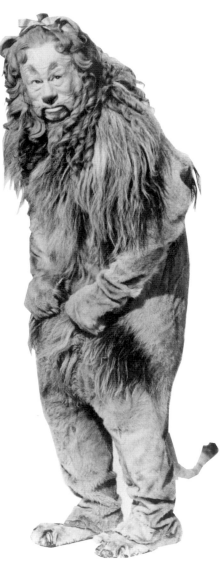

The Ass in the Lion's Skin

Aesop (6th century B.C.)

Rendered into verse by William Ellery Leonard

An Ass put on a Lion's skin and went
About the forest with much merriment,
Scaring the foolish beasts by brooks and rocks,
Till at last he tried to scare the Fox.
But Reynard, hearing from beneath the mane
That raucous voice so petulant and vain,
Remarked, 'O Ass, I too would run away,
But that I know your old familiar bray.'

That's just the way with asses, just the way.

A Cowardly Lion
Bert Lahr in the movie version
of *The Wizard of Oz*, 1939

41

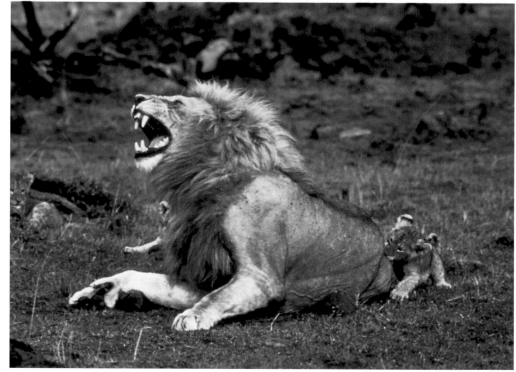

Male Lion and Cubs,
Masai Mara, Kenya

The Lion
Hilaire Belloc (1870–1953)

The Lion, the Lion, he dwells in the waste,
He has a big head and a very small waist;
But his shoulders are stark, and his jaws they are grim,
And a good little child will not play with him.

Ars Poetica
Charles Wright (born 1935)

I like it back here

Under the green swatch of the pepper tree and the aloe vera.
I like it because the wind strips down the leaves without a word.
I like it because the wind repeats itself,
 and the leaves do.

I like it because I'm better here than I am there,

Surrounded by fetishes and figures of speech:
Dog's tooth and whale's tooth, my father's shoe, the dead weight
Of winter, the inarticulation of joy . . .

The spirits are everywhere.

And once I have them called down from the sky, and spinning and
 dancing in the palm of my hand,
What will it satisfy?
 I'll still have

The voices rising out of the ground,
The fallen star my blood feeds,
 this business I waste my heart on.

And nothing stops that.

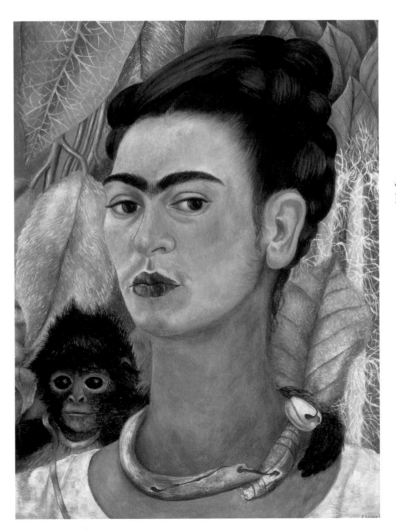

Self-Portrait with Monkey
Frida Kahlo, 1938

Naming the Animals
from The Book of Genesis 2:19

And out of the ground the Lord God formed every beast of the field, and every fowl of the air;
and brought them unto Adam to see what he would call them:
and whatsoever Adam called every living creature,
that was the name thereof.

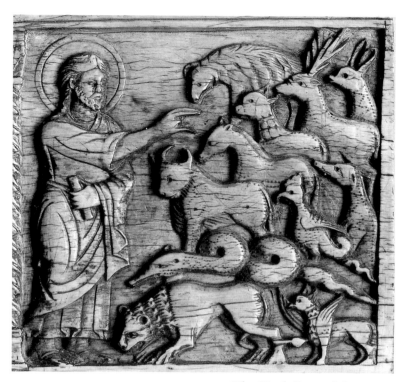

The Sixth Day of Creation
Italian, about 1085

If They Spoke
Mark Van Doren (1894–1972)

The animals will never know;
Could not find out; would scarcely care
That all their names are in our books,
And all their images drawn bare.

What names? They have not heard the sound.
Nor in their silence thought the thing.
They are not notified they live;
Nor ask who set them wandering.

Simply they are. And so with us;
And they would say it if they spoke;
And we might listen; and the world
Be uncreated at one stroke.

The Tiger
William Blake (1757–1827)

Tiger, tiger, burning bright
In the forests of the night,
What immortal hand or eye
Could frame thy fearful symmetry?

In what distant deeps or skies
Burnt the fire of thine eyes?
On what wings dare he aspire?
What the hand dare seize the fire?

And what shoulder and what art
Could twist the sinews of thy heart?
And, when thy heart begins to beat,
What dread hand and what dread feet?

What the hammer? What the chain?
In what furnace was thy brain?
What the anvil? What dread grasp
Dare its deadly terrors clasp?

When the stars threw down their spears,
And water'd heaven with their tears,
Did He smile His work to see?
Did He who made the lamb make thee?

Tiger, tiger, burning bright
In the forests of the night,
What immortal hand or eye
Dare frame thy fearful symmetry?

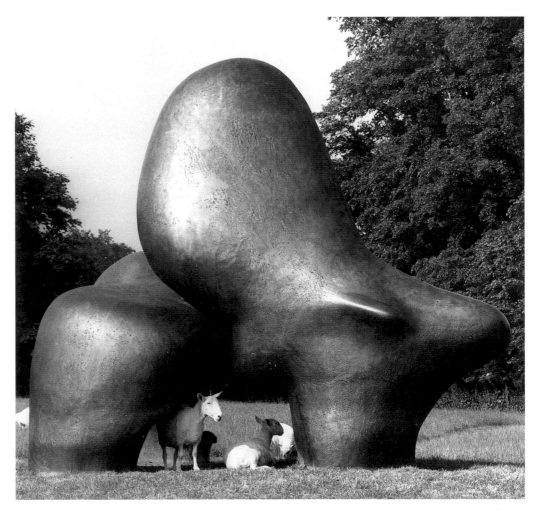

Sheep Piece
Henry Moore, 1971–72
Photograph by David Finn

Fear No Evil

from Psalm 23

The Lord is my shepherd; I shall not want.
He maketh me to lie down in green pastures: He leadeth me beside the still waters.
He restoreth my soul: He leadeth me in the paths of righteousness for His name's sake.
Yea, though I walk through the valley of the shadow of death, I will fear no evil:
for Thou art with me; Thy rod and Thy staff they comfort me.

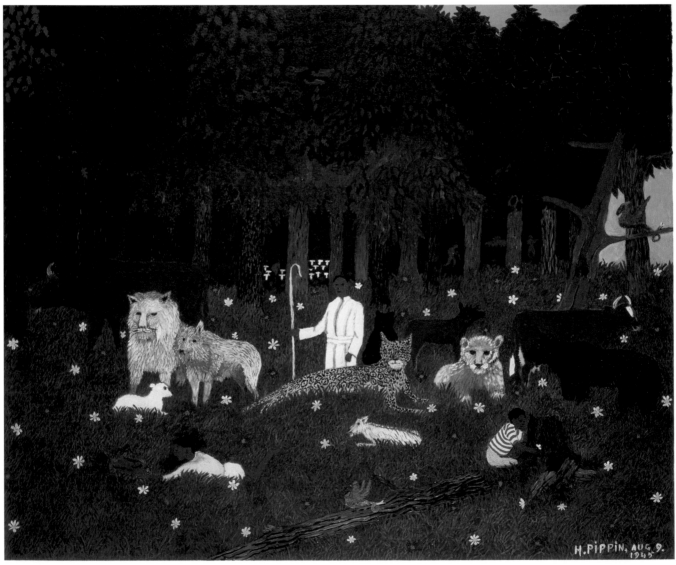

Holy Mountain III
Horace Pippin, 1945

The Heaven of Animals

James Dickey (born 1923)

Here they are. The soft eyes open.
If they have lived in a wood
It is a wood.
If they have lived on plains
It is grass rolling
Under their feet forever.

Having no souls, they have come,
Anyway, beyond their knowing.
Their instincts wholly bloom
And they rise.
The soft eyes open.

To match them, the landscape flowers,
Outdoing, desperately
Outdoing what is required:
The richest wood,
The deepest field.

For some of these,
It could not be the place
It is, without blood.
These hunt, as they have done,
But with claws and teeth grown perfect,

More deadly than they can believe.
They stalk more silently,
And crouch on the limbs of trees,
And their descent
Upon the bright backs of their prey

May take years
In a sovereign floating of joy.
And those that are hunted
Know this as their life,
Their reward: to walk

Under such trees in full knowledge
Of what is in glory above them,
And to feel no fear,
But acceptance, compliance.
Fulfilling themselves without pain

At the cycle's center,
They tremble, they walk
Under the tree,
They fall, they are torn,
They rise, they walk again.

The Labyrinth

from Atlas
Jorge Luis Borges (1899–1986)
translated from Spanish by Anthony Kerrigan

This is the labyrinth of Crete. This is the labyrinth of Crete whose center was the Minotaur. This is the labyrinth of Crete whose center was the Minotaur that Dante imaged as a bull with a man's head . . .

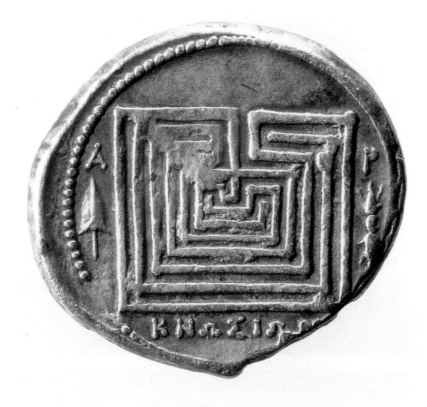

Labyrinth on a silver coin from Knossos, Crete about 350–280 B.C.

In ancient Greek mythology, the labyrinth was an underground maze on the island of Crete, so cleverly designed that almost no one could get away from the monster that lived there, the Minotaur.

An English Wood

Robert Graves (1895–1985)

This valley wood is pledged
To the set shape of things,
And reasonably hedged:
Here are no harpies fledged,
No rocs may clap their wings,
Nor gryphons wave their stings.
Here, poised in quietude,
Calm elementals brood
On the set shape of things:
They fend away alarms
From this green wood.
Here nothing is that harms—
No bulls with lungs of brass,
No toothed or spiny grass,
No tree whose clutching arms
Drink blood when travellers pass,
No mount of glass;
No bardic tongues unfold
Satires or charms.
Only, the lawns are soft,
The tree-stems, grave and old;
Slow branches sway aloft,
The evening air comes cold,
The sunset scatters gold.
Small grasses toss and bend,
Small pathways idly tend
Towards no fearful end.

The Minotaur

from The Divine Comedy, *Part I:*
"The Inferno," Canto XXII: 22–30
Dante Alighieri (1265–1321)
translated from Italian by John Ciardi

As a bull that breaks its chains just when the knife
 has struck its death-blow cannot stand nor run
 but leaps from side to side with its last life—

so danced the Minotaur, and my shrewd Guide
 cried out: "Run now! While he is blind with rage!
 Into the pass, quick, and get over the side!"

So we went down across the shale and slate
 of that ruined rock, which often slid and shifted
 under me at the touch of living weight.

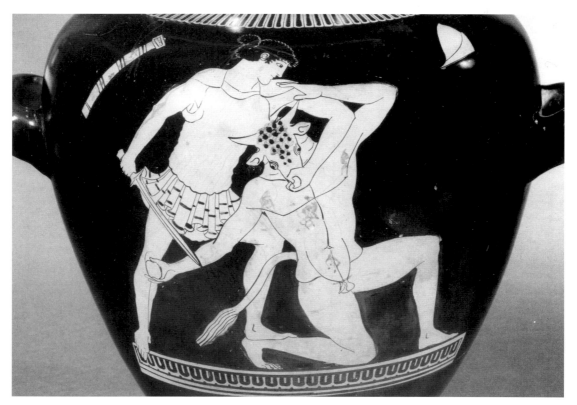

Theseus Killing the Minotaur
about 480 B.C.

Theseus, a mythical hero, either killed the Minotaur or outsmarted it and escaped from
the maze—depending on which version of the story we read.

Jabberwocky

from Through the Looking-Glass
Lewis Carroll (1832–1898)

’Twas brillig, and the slithy toves
 Did gyre and gimble in the wabe;
All mimsy were the borogoves,
 And the mome raths outgrabe.

“Beware the Jabberwock, my son!
 The jaws that bite, the claws that catch!
Beware the Jubjub bird and shun
 The frumious Bandersnatch!”

He took his vorpal sword in hand:
 Long time the manxome foe he sought—
So rested he by the Tumtum tree,
 And stood awhile in thought.

Crackbeak
Dougal Dixon and Martin
Knowelden, 1988

The imaginary “dinosaur”
seems to resemble Lewis
Carroll’s jabberwock, whose
name has become synonymous
with meaningless writing or talk.

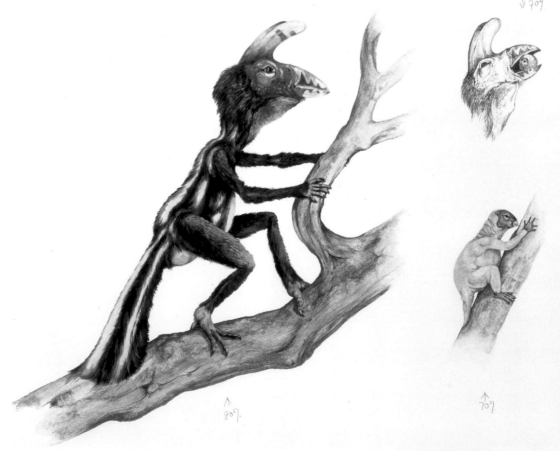

50

And as in uffish thought he stood,
 The Jabberwock, with eyes of flame,
Came whiffing through the tulgey wood,
 And burbled as it came!

One, two! One, two! And through and
through
 The vorpal blade went snicker-snack!
He left it dead, and with its head
 He went galumphing back.

"And hast thou slain the Jabberwock?
 Come to my arms, my beamish boy!
O frabjous day! Callooh! Callay!"
 He chortled in his joy.

'Twas brillig, and the slithy toves
 Did gyre and gimble in the wabe;
All mimsy were the borogoves,
 And the mome raths outgrabe.

To a Squirrel at Kyle-na-no
W. B. Yeats (1865–1939)

Come play with me;
Why should you run
Through the shaking tree
As though I'd a gun
To strike you dead?
When all I would do
Is to scratch your head
And let you go.

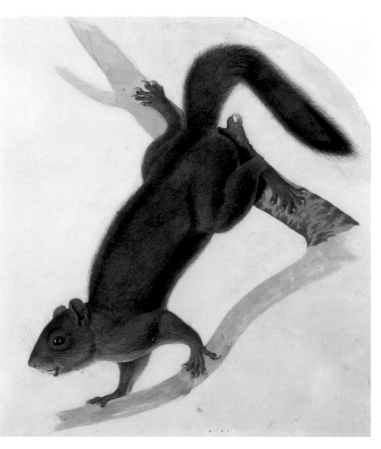

Soft-Haired Squirrel
John James Audubon, about 1845

Kyle-na-no, in western Ireland, was a favorite
place of the poet Yeats.

51

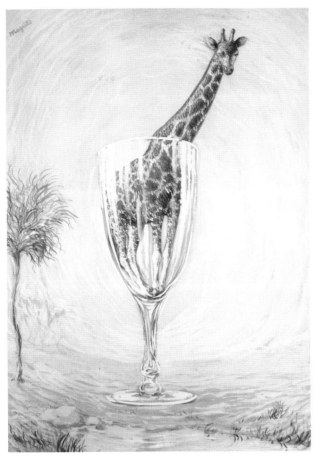

Le Bain Cristal (The Glass Bath)
René Magritte, 1946

To a Giraffe

Marianne Moore (1887–1972)

If it is unpermissible, in fact fatal
to be personal and undesirable

to be literal—detrimental as well
if the eye is not innocent—does it mean that

one can live only on top leaves that are small
reachable only by a beast that is tall?—

of which the giraffe is the best example—
the unconversational animal.

When plagued by the psychological,
a creature can be unbearable

that could have been irresistible,
or to be exact, exceptional

since less conversational
than some emotionally-tied-in-knots animal.

After all
consolations of the metaphysical
can be profound. In Homer, existence

is flawed; transcendence, conditional;
"the journey from sin to redemption, perpetual."

Come into Animal Presence
Denise Levertov (born 1923)

Come into animal presence.
No man is so guileless as
the serpent. The lonely white
rabbit on the roof is a star
twitching its ears at the rain.
The llama intricately
folding its hind legs to be seated
not disdains but mildly
disregards human approval.
What joy when the insouciant
armadillo glances at us and doesn't
quicken his trotting
across the track into the palm brush.

What is this joy? That no animal
falters, but knows what it must do?
That the snake has no blemish,
that the rabbit inspects his strange surroundings
in white star-silence? The llama
rests in dignity, the armadillo
has some intention to pursue in the palm-forest.
Those who were sacred have remained so,
holiness does not dissolve, it is a presence
of bronze, only the sight that saw it
faltered and turned from it.
An old joy returns in holy presence.

New York City, 1957
Inge Morath

A real llama from South America took
a cab ride in Manhattan.

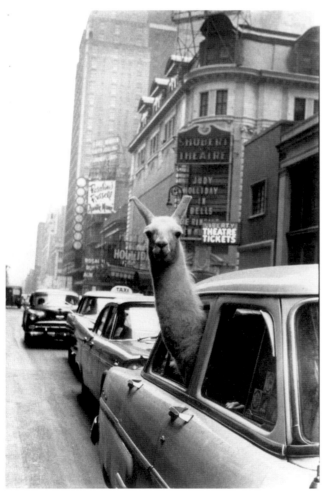

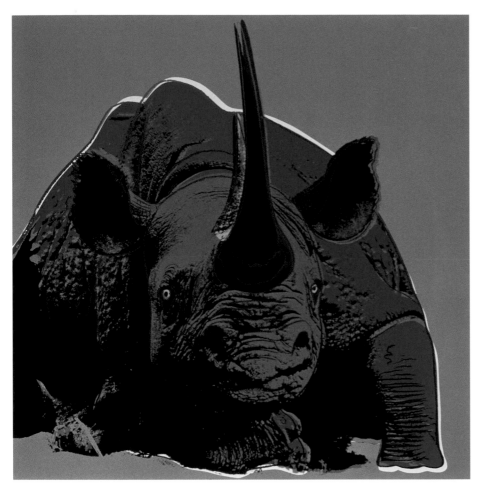

Endangered Species: Black Rhinoceros
Andy Warhol, 1983

The Rhinoceros
Ogden Nash (1902–1971)

The Rhino is a homely beast,
For human eyes he's not a feast,
But you and I will never know
Why Nature chose to make him so.
Farewell, farewell, you old rhinoceros,
I'll stare at something less prepoceros.

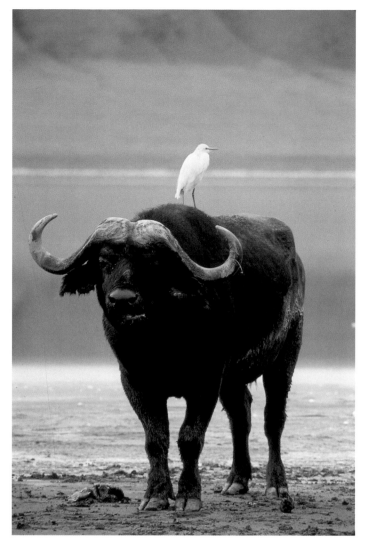

Cape Buffalo with Cattle Egret

Egrets (a variety of heron) are found in many places, including Asia and Africa. Here we see one on the Serengeti plain, Tanzania.

Egrets

Tu Mu (803–852)

translated from Chinese by Irving Y. Lo

In cloaks of snow, hairs snow-white, and beaks of blue
 jade,
They gather to hunt for fish, their reflection in the
 brook;
Startled they fly off, cast their distant shadows on
 green hills.
And all the blossoms of a pear tree fall in the evening
 breeze.

The Uninvited

William D. Mundell (born 1913)

There is never an open door to the wild beasts' home,
And stepstones leading to their secret wood
Are watched by snails with horns and ants with wings.
You are tripped by little things: a spider's thread
That rings a hundred lead bells down their trails;
A twig will break and some old inching worm
Will turn his head, concerned because of all
The needless noise you make. Your anxious shadow,
Like a nosing hound, will race with deer mice
To their grassy nests, and, headlong on the path you found,
It will invade the deeper shade where partridge rest
And send them shuddering across the disturbed hill.
You will be seen from mounds where hooded woodchucks cull
Their gravel acre; where, from lonely cells, they come
To work their sparse monk gardens for their fare;
Where all the braided briars and underbrush
Guard the low runs used by the fox and hare.
"There! There is the open door!" you'll say,
Pointing to where a wide space runs,
An open corridor through pillared trees.
Then you will know that squirrels claim the place
By sudden show and chatter, and, as though
To mock your thought, they'll stir a noisy whirlwind
In the leaves. Always you'll walk announced
To hedgehog hovels. Your pace will be regarded
From each wildcat lair. Your hour of coming
Will be drummed through all the forest rooms.
Your show of strength will be considered
From each hilltop tower. Your journey will be timed
By beasts beyond your sight, and, should you follow,
Though moving cautiously, the wary host, like startled deer
In flight, will all go bounding back, until at last
They move into the trackless cover of the night.

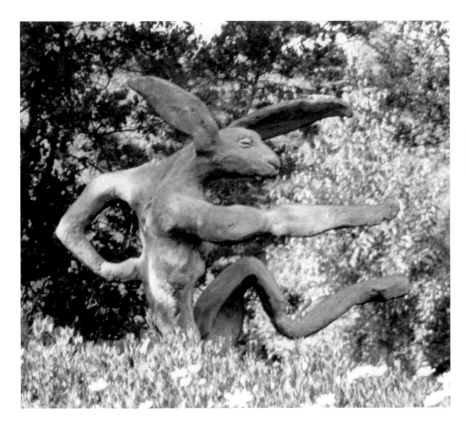

*Nijinski Hare by
Barry Flanagan, 1989
Shirley Ross Davis, 1995*

Spider
Matsuo Bashō (1644–1694)

ith what voice,
And what song would you sing, spider,
In this autumn breeze?

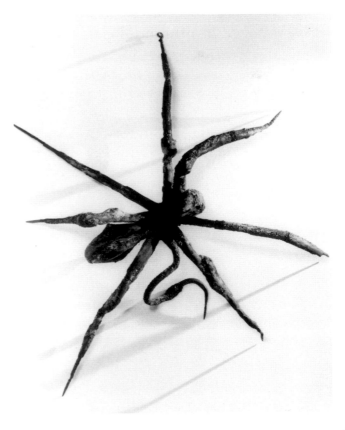

Spider
Louise Bourgeois, 1994

How to See Deer

Philip Booth (born 1925)

Forget roadside crossings.
Go nowhere with guns.
Go elsewhere your own way,

lonely and wanting. Or
stay and be early:
next to deep woods

inhabit old orchards.
All clearings promise.
Sunrise is good,

and fog before sun.
Expect nothing always;
find your luck slowly.

Wait out the windfall.
Take your good time
to learn to read ferns;

make like a turtle:
downhill toward slow water.
Instructed by heron,

drink the pure silence.
Be compassed by wind.
If you quiver like aspen

trust your quick nature:
let your ear teach you
which way to listen.

You've come to assume
protective color; now
colors reform to

new shapes in your eye.
You've learned by now
to wait without waiting;

as if it were dusk
look into light falling:
in deep relief

things even out. Be
careless of nothing. See
what you see.

Deer Drinking
Winslow Homer, 1892

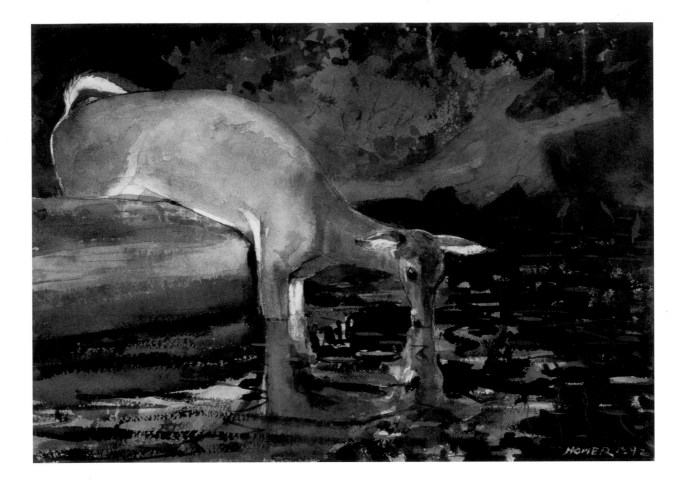

The Color of Many Deer Running

Linda Gregg (born 1942)

The air fresh, as it has been for days.
Upper sky lavender. Deer on the far hill.
The farm woman said they would be gone
when I got there as I started down the lane.
Jumped the stream. Went under great eucalyptus
where the ground was stamped bare by two bulls
who watched from the other side of their field.
The young deer were playing as the old ate
or guarded. Then all were gone, leaping.
Except one looking down from the top.
The ending made me glad. I turned toward
the red sky and ran back down to the farm,
the man, the woman, and the young calves.
Thinking that as I grow older I will lose
my color. Will turn tan and gray like the deer.
Not one deer, but when many of them run away.

The Pasture

Robert Frost (1874–1963)

I'm going out to clean the pasture spring;
I'll only stop to rake the leaves away
(And wait to watch the water clear, I may):
I shan't be gone long.—You come too.

I'm going out to fetch the little calf
That's standing by the mother. It's so young
It totters when she licks it with her tongue.
I shan't be gone long.—You come too.

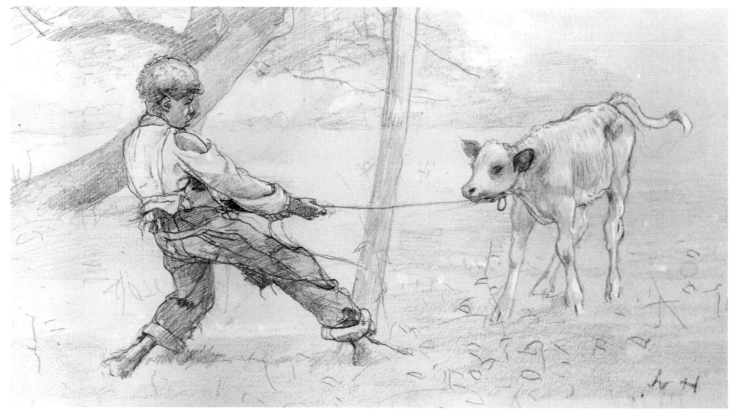

The Unruly Calf
Winslow Homer, about 1875

MacDonald's Farm

lyrics of an old song

Old MacDonald had a farm, E - I - E - I - O,
and on this farm he had some hogs, E - I - E - I - O,
with an *oink oink* here and an *oink oink* there,
here an *oink*, there an *oink*, ev'rywhere an *oink oink*,
Old MacDonald had a farm, E - I - E - I - O.

Man on a Hog
Clark Coe, about 1890

A Riddle

Jonathan Swift (1667–1745)

We are little airy creatures,
 All of different voice and features;
One of us in glass is set,
One of us you'll find in jet.
T'other you may see in tin,
And the fourth a box within.
If the fifth you should pursue,
It can never fly from you.

The answer to Swift's riddle is
the five vowels: *a* in glass, *e* in jet,
i in tin, *o* in box, *u* in you.

The Telephone

Kornei Chukovsky (1882–1969)

translated from Russian by William Jay Smith

The telephone rang.
"Hello! Who's there?"
"The Polar Bear."
"What do you want?"
"I'm calling for the Elephant."
"What does *he* want?"
"He wants a little
Peanut brittle."

"Peanut brittle! . . . And for whom?"
"It's for his little
Elephant sons."
"How much does he want?"
"Oh, five or six tons.
Right now that's all
That they can manage—they're quite small."

The telephone rang. The Crocodile
Said, with a tear,
"My dearest dear,
We don't need umbrellas or mackintoshes;
My wife and baby need new galoshes;
Send us some, please!"
"Wait—wasn't it you
Who just last week ordered two
Pairs of beautiful brand-new galoshes?"

"Oh, those that came last week—they
Got gobbled up right away;
And we just can't wait—
For supper tonight
We'd like to sprinkle on our goulashes
One or two dozen delicious galoshes!"
The telephone rang. The Turtle Doves
Said: "Send us, please, some long white gloves!"

It rang again; the Chimpanzees
Giggled: "Phone books, please!"

The telephone rang. The Grizzly Bear
Said: "Grr—Grr!"
"Stop, Bear, don't growl, don't bawl!
Just tell me what you want!"
But on he went—"Grr! Grrrrrrr . . ."
Why; what for?
I couldn't make out;
I just banged down the receiver.

The telephone rang. The Flamingos
Said: "Rush us over a bottle of those
Little pink pills! . . .
 We've swallowed every frog in the lake,
And are croaking with a stomachache!"

The Pig telephoned. Ivan Pigtail
Said: "Send over Nina Nightingale!
Together, I bet
We'll sing a duet
That opera lovers will never forget!
I'll begin—"
 "No, you won't. The Divine Nightingale
Accompanying a Pig! Ivan Petrovich,
No!
You'd better call on Katya Crow!"

The telephone rang. The Polar Bear
Said: "Come to the aid of the Walrus, Sir!
He's about
 to choke
 on a fat
 oyster!"

And so it goes. The whole day long
The same silly song:
 Ting-a-ling!
 Ting-a-ling!
 Ting-a-ling!
A Seal telephones, and then a Gazelle,
And just now two very queer
Reindeer,
Who said, "Oh, dear, oh, dear,
Did you hear? Is it true
That the Bump-Bump Cars at the Carnival
Have all burned up?"

"Are you out of your minds, you silly Deer?
The Merry-Go-Round
At the Carnival still goes round,
And the Bump-Bump Cars are running, too;
You ought to go right
Out to the Carnival this very night
And buzz around in the Bump-Bump Cars
And ride the Ferris Wheel up to the stars!"

But they wouldn't listen, the silly Deer;
They just went on: "Oh, dear, oh, dear,
Did you hear? Is it true
That the Bump-Bump Cars
At the Carnival
Have all burned up?"

Lobster Telephone
Salvador Dalí, 1936

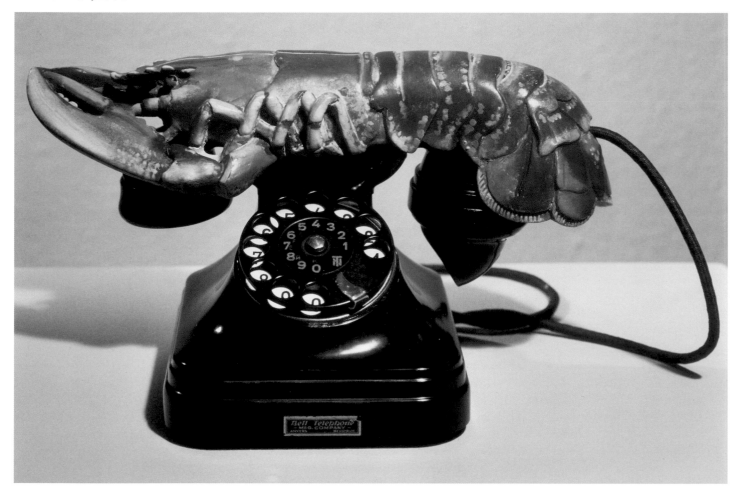

How wrong-headed Reindeer really are!

At five in the morning the telephone rang:
The Kangaroo
Said: "Hello, Rub-a-dub-dub,
How are you?"
Which really made me raving mad.
"I don't know any Rub-a-dub-dub,
Soapflakes! Pancakes! Bubbledy-bub
Why don't you
Try calling Pinhead Zero Two! . . ."

I haven't slept for three whole nights.
I'd really like to go to bed
And get some sleep.
But every time I lay down my head
The telephone rings.

Study of a Young Hippopotamus
Edwin Landseer, 1850

"Who's there—Hello!"
"It's the Rhino."
"What's wrong, Rhino?"
"Terrible trouble,
Come on the double!"
"What's the matter? Why the fuss?"
"Quick. Save him . . ."
"Who?"
"The hippopotamus.
He's sinking out there in that awful swamp . . ."
"In the swamp?"
"Yes, he's stuck."
"And if you don't come right away,
He'll drown in that terrible damp
And dismal swamp.
He'll die, he'll croak—oh, oh, oh,
Poor Hippo-
 po-
 po"

"Okay . . .
 I'm coming
Right away!"

Whew: What a job! You need a truck
To help a Hippo when he's stuck!

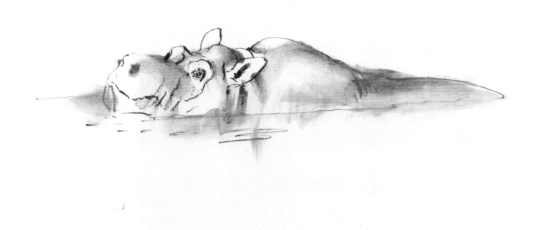

The Owl

Edward Thomas (1887–1917)

Downhill I came, hungry, and yet not starved;
Cold, yet had heat within me that was proof
Against the North wind; tired, yet so that rest
Had seemed the sweetest thing under a roof.

Then at the inn I had food, fire, and rest,
Knowing how hungry, cold, and tired was I.
All of the night was quite barred out except
An owl's cry, a most melancholy cry

Shaken out long and clear upon the hill,
No merry note, nor cause of merriment,
But one telling me plain what I escaped
And others could not, that night, as in I went.

And salted was my food, and my repose,
Salted and sobered, too, by the bird's voice
Speaking for all who lay under the stars,
Soldiers and poor, unable to rejoice.

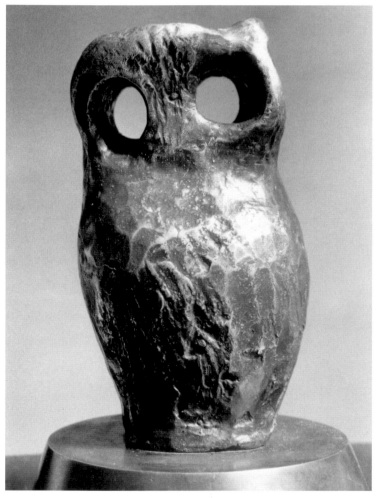

Owl
Henry Moore, 1966

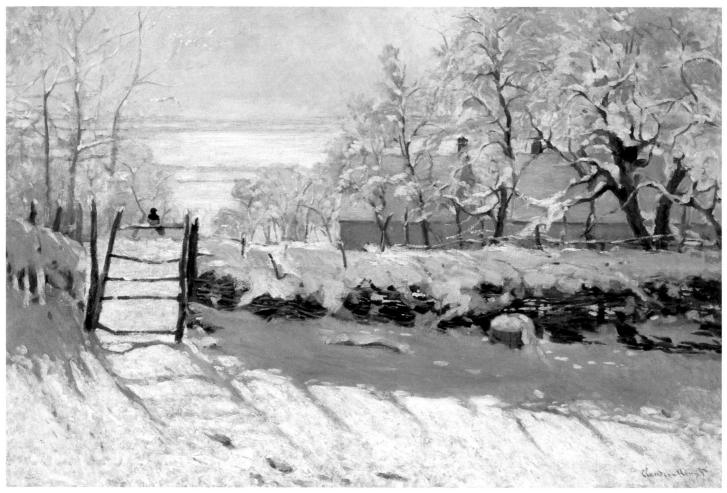

La Pie (The Magpie)
Claude Monet, 1868–69

Storm Fear

Robert Frost (1874–1963)

When the wind works against us in the dark,
And pelts with snow
The lower-chamber window on the east,
And whispers with a sort of stifled bark,
The beast,
"Come out! Come out!"—
It costs no inward struggle not to go,
Ah, no!
I count our strength,

Two and a child,
Those of us not asleep subdued to mark
How the cold creeps as the fire dies at length—
How drifts are piled,
Dooryard and road ungraded,
Till even the comforting barn grows far away,
And my heart owns a doubt
Whether 'tis in us to arise with day
And save ourselves unaided.

The Gift of Calling

from "Decoys"
Leslie Norris (born 1921)

There are men, they are born with it,
who have the gift of calling.

They live in cottages on the saltings,
or if in villages, move quietly by night.

Nothing changes in their country but they know it;
the angle of a gate, a dropped branch, shifts in the wind.

For them, the sky fills with wildfowl. The lanes of flight
clamour for them, for them sanderling

and redshank patter at the tide's withdrawing runnels.
They turn, in quiet beds, at a flake of snow.

When they call, when they squat in a hide
or hide in a thick of bush,

they blow through cupped hands
for a meeting of animals and birds.

Call again and again, the note rising,
an elegy for vulnerable creatures,

the hare, the partridge, runners and low fliers.
And for the waterbirds, for rafts of teal,

the pied shelduck, for skeins of geese,
brent goose, snow goose, pinkfoot, Canada,

the little bean goose, hardy in the air,
the royal swan, the whooper,

all humble on land, on their pliable webs.
Let the men put away rapacious lead, let them be still.

The birds have given them the wide, cold sky,
they have given them dreams of innocence,

they have given them voices.

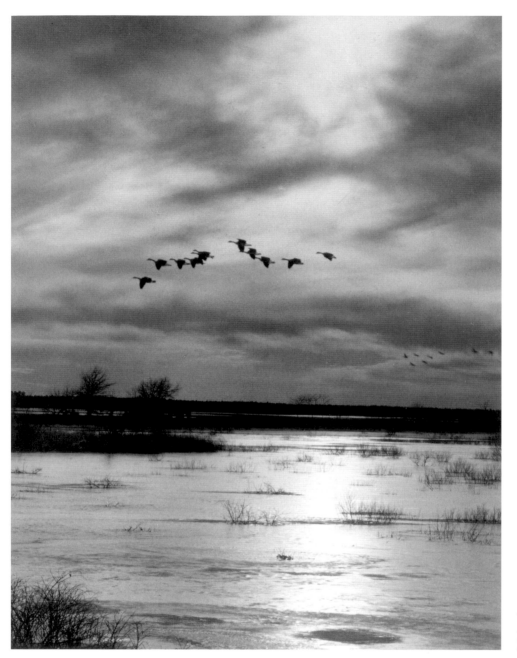

Maryland,
Eastern Shore
M. E. Warren, 1982

Wild Geese

from Leaves of Grass
Walt Whitman (1819–1892)

The wild gander leads his flock through the cool night,
Ya-honk! he says, and sounds it down to me like an invitation;
The pert may suppose it meaningless, but I listen closer,
I find its purpose and place up there toward the November sky.

Allie

Robert Graves (1895–1985)

Allie, call the birds in,
 The birds from the sky!
Allie calls, Allie sings,
 Down they all fly:
First there came
Two white doves,
 Then a sparrow from his nest,
Then a clucking bantam hen,
 Then a robin red-breast.

Allie, call the beasts in,
 The beasts, every one!
Allie calls, Allie sings,
 In they all run:
First there came
Two black lambs,
 Then a grunting Berkshire sow,
Then a dog without a tail,
 Then a red and white cow.

Allie, call the fish up,
 The fish from the stream!
Allie calls, Allie sings,
 Up they all swim:
First there came
Two gold fish,
 A minnow and a miller's thumb,
Then a school of little trout,
 Then the twisting eels come.

Allie, call the children,
 Call them from the green!
Allie calls, Allie sings,
 Soon they run in:
First there came
Tom and Madge,
 Kate and I who'll not forget
How we played by the water's edge
 Till the April sun set.

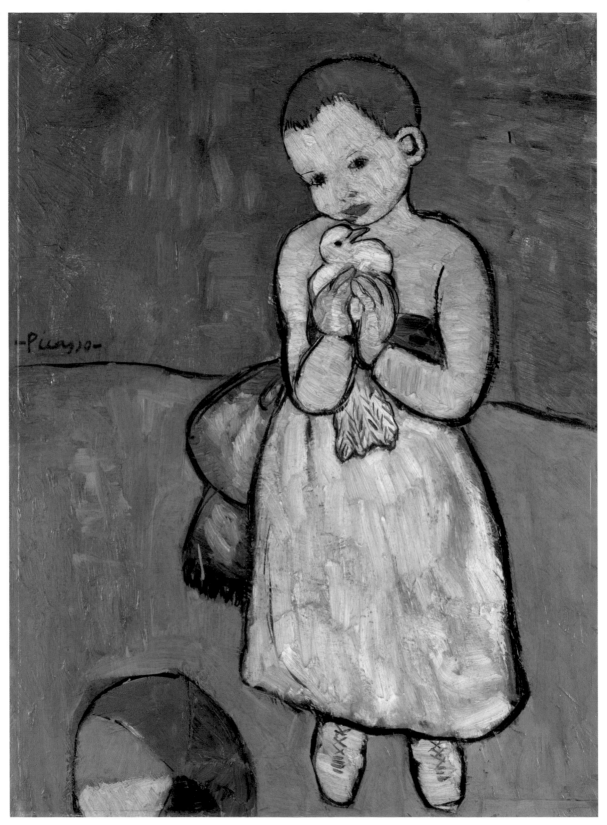

Child with Dove
Pablo Picasso, 1901

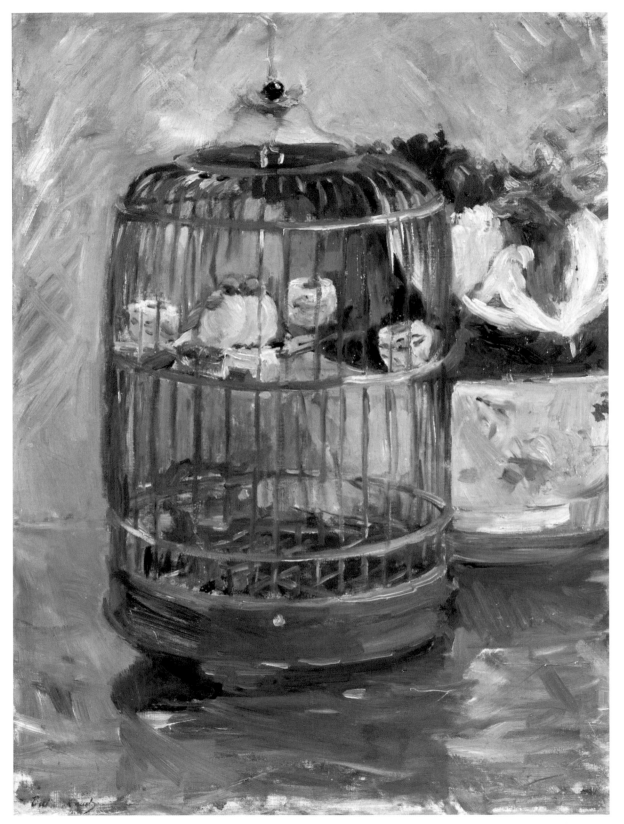

The Cage
Berthe Morisot, 1885

How to Do the Portrait of a Bird

Jacques Prévert (1900–1977)

translated from French by Charles Sullivan

First paint a cage
with an open door,
then paint
something pretty
something simple
something splendid
something useful
for the bird.

Then place the canvas against a tree
in a garden
in a park
or in a forest.

Hide behind the tree
without saying anything
without moving.

Sometimes the bird arrives quickly
but it can just as likely take years
before it decides.
Don't be discouraged.
Wait,
wait for years if you must—
the speed or slowness of the bird's arrival
having no connection
with the success of the picture.

When the bird arrives,
if it arrives,
keep the deepest silence,
wait for the bird to enter the cage,
and when it has entered
gently close the door with your brush,
then
remove one by one all the bars of the cage
taking care not to touch any of the bird's feathers.

After this, paint the picture of the tree,
choosing the most beautiful of its branches
for the bird.
Paint too the green foliage and the freshness of the wind,
the dust through the sunlight,
and the sounds of the grass's insects in the heat of summer,
and then wait for the bird to decide to sing.

If the bird doesn't sing
this is a bad sign,
a sign that the painting is bad;
but if it does sing, this is a good sign,
a sign that you can sign.
So very gently pluck
one of the bird's feathers
and write your name in a corner of the picture.

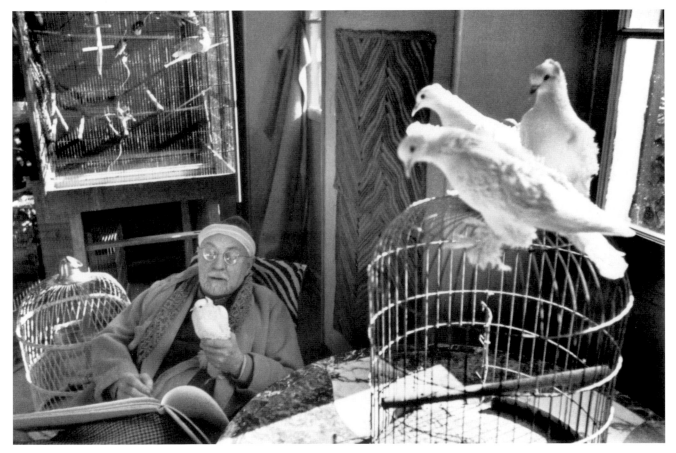

Henri Matisse in his studio with doves, Vence, France
Henri Cartier-Bresson, 1946

Four Ducks on a Pond
William Allingham (1824–1889)

Four ducks on a pond,
A grass-bank beyond,
A blue sky of spring,
White clouds on the wing:
What a little thing
To remember for years—
To remember with tears!

The Lobster Quadrille
from Alice's Adventures in Wonderland
Lewis Carroll (1832–1898)

"Will you walk a little faster?"
said a whiting to a snail,
"There's a porpoise close behind us,
 and he's treading on my tail!
See how eagerly the lobsters and
 the turtles all advance!
They are waiting on the shingle—
 will you come and join the dance?
Will you, won't you, will you, won't you,
 will you join the dance?
Will you, won't you, will you, won't you,
 will you join the dance?
You can really have no notion
 how delightful it will be

Summertime
Mary Cassatt, 1894

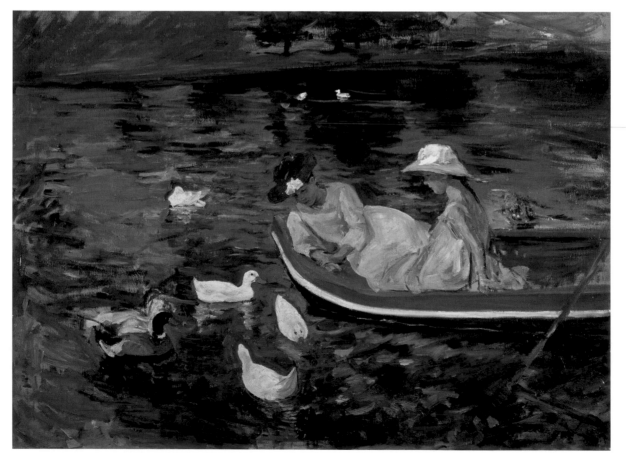

When they take us up and throw us
 with the lobsters, out to sea!"
But the snail replied, "Too far, too far!"
 and gave a look askance—
Said he thanked the whiting kindly,
 but he would not join the dance.
Would not, could not, would not, could not,
 could not join the dance.
Would not, could not, would not, could not,
 could not join the dance.

"What matters it how far we go?"
 his scaly friend replied,
"There is another shore, you know,
 upon the other side.
The further off from England,
 the nearer is to France—
Then turn not pale, beloved snail,
 but come and join the dance.
Will you, won't you, will you, won't you,
 will you join the dance?
Will you, won't you, will you, won't you,
 will you join the dance?"

Girls with Lobster
Winslow Homer, 1873

A "quadrille" is a kind of square dance.

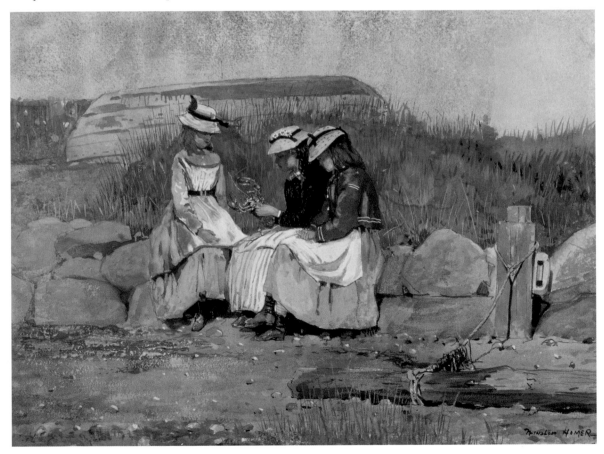

The Cow
Alexander Calder, 1930

The Cow in Apple Time
Robert Frost (1874–1963)

Something inspires the only cow of late
To make no more of a wall than an open gate,
And think no more of wall-builders than fools.
Her face is flecked with pomace and she drools
A cider syrup. Having tasted fruit,
She scorns a pasture withering to the root.
She runs from tree to tree where lie and sweeten
The windfalls spiked with stubble and worm-eaten.
She leaves them bitten when she has to fly.
She bellows on a knoll against the sky.
Her udder shrivels and the milk goes dry.

The Purple Cow
Gelett Burgess (1866–1951)

I never saw a Purple Cow,
 I never hope to see one;
But I can tell you, anyhow,
 I'd rather see than be one.

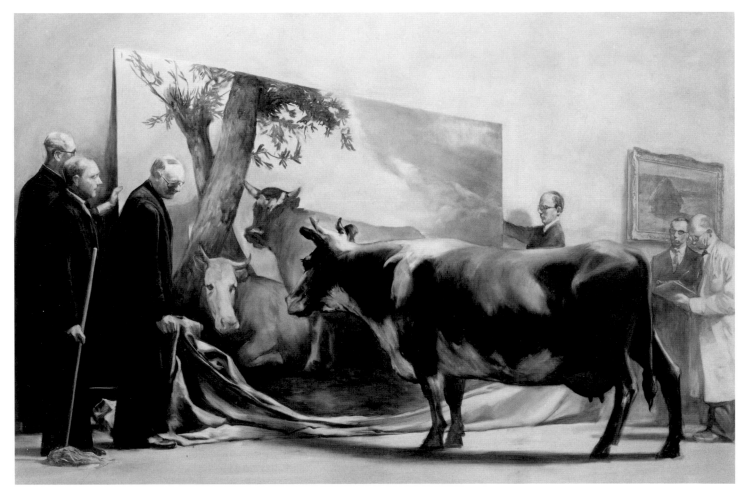

The Innocent Eye Test
Mark Tansey, 1981

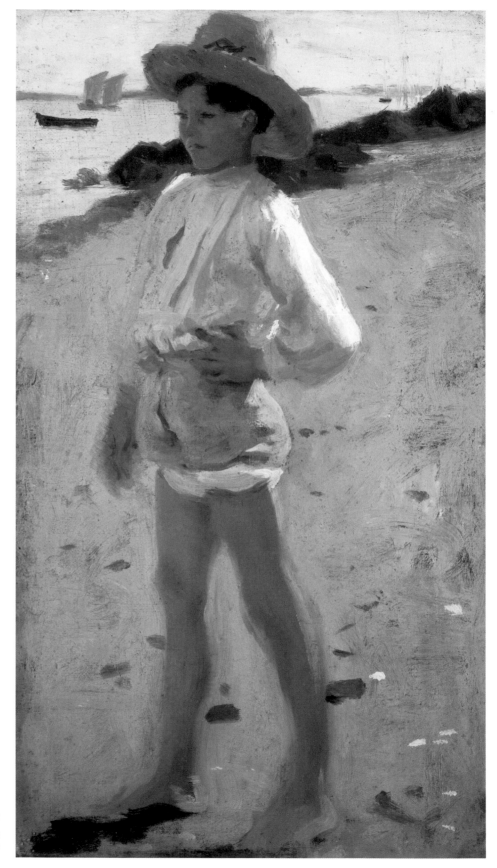

Young Boy on the Beach, sketch for
Oyster Gatherers of Cancale
John Singer Sargent, 1877

Daybreak
Galway Kinnell (born 1927)

On the tidal mud, just before sunset,
dozens of starfishes
were creeping. It was
as though the mud were a sky
and enormous, imperfect stars
moved across it as slowly
as the actual stars cross heaven.
All at once they stopped,
and as if they had simply
increased their receptivity
to gravity they sank down
into the mud; they faded down
into it and lay still; and by the time
pink of sunset broke across them
they were as invisible
as the true stars at daybreak.

Cat Talk
Shirley Graves Cochrane (born 1939)

My grandmother could talk to cats
in their own language;
she would start with a low *Mariah*—
that would get their attention
(usually females—only rarely did she
talk to Toms)
and they would stare into her face, astonished
at this cat's voice
coming from a woman's body.

Next she would utter a firm *Josiah,* producing
greater astonishment.
Then she would try *belledeen, belledeen*
at which point
the cat would climb into her lap, place its paws
on her shoulders
and gaze into her soul.

Today, listening closely, I can hear cats pronounce
these very sounds
but when *I* try a tentative *Mariah,*
they merely lift a tongue
from fur
and when I say *Josiah,* they resume their grooming.
If I ring out a strong *belledeen,*
their eyes tell me
You are a fake—we are not fooled.

They know, these felines, who their sisters are.
Surely as with some esoteric Asian language
there is a trick
of rhythm or stress, some click of the tongue
some warble mastered
that separates real cat-talkers from
pretenders such as I.

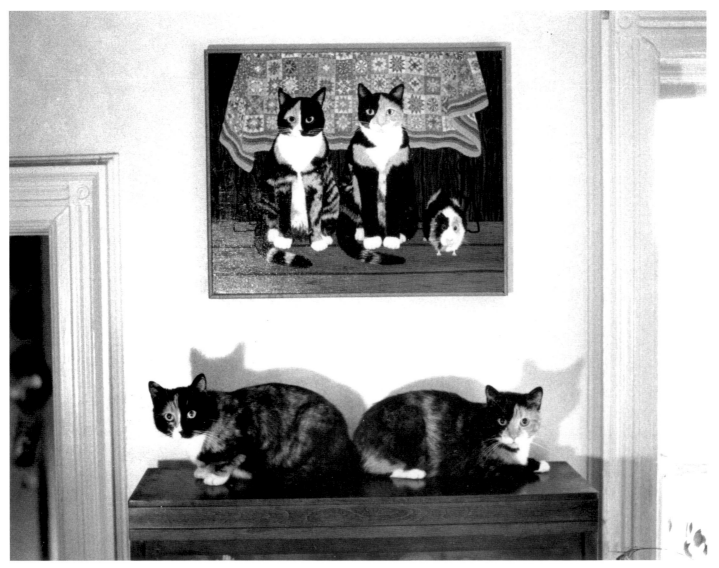

Cat Couples (Picasso and Putz in front of their portrait by Mimi Vang Olsen)
Joan Baron, 1985

Moment

Barbara Angell (1930–1990)

I saw September come
in the shape of a spotted cat

at four o'clock
on a Sunday afternoon
where August ended

in a glittering street
of brownstone houses
bleaching in the sun.

In a moment, as of
the space between breaths

the cat came
rippling along a window ledge
through a stripe of light

and I saw September
creeping in,
golden, dusty,
unnamed.

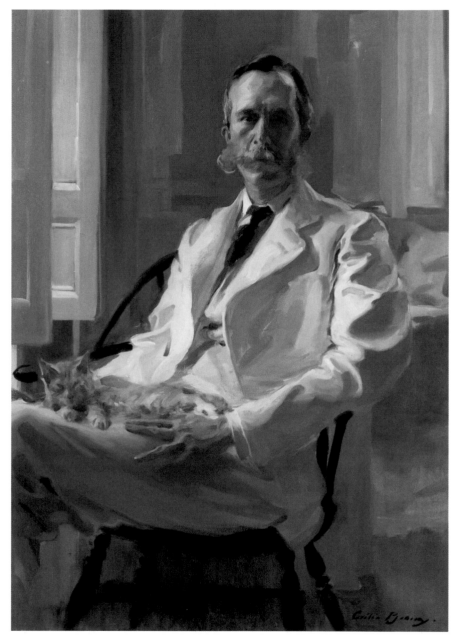

Man with the Cat (Henry Sturgis Drinker)
Cecilia Beaux, 1898

mice
Valerie Worth (1933–1994)

M ice
Find places
In places,

A dark
Hall behind
The hall,

Odd rooms
That other
Rooms hide:

A world
Inside
The wide world

And space enough,
Even in
Small spaces.

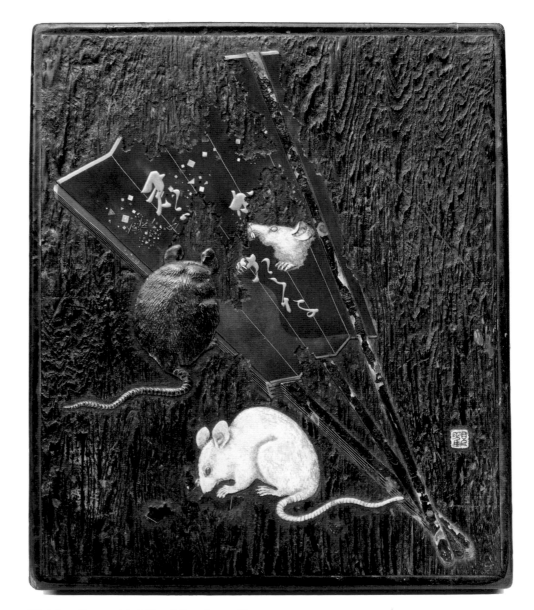

Writing Box with Mice Chewing a Fan
Ogawa Haritsu (Ritsuo), Japanese, 17th–18th century

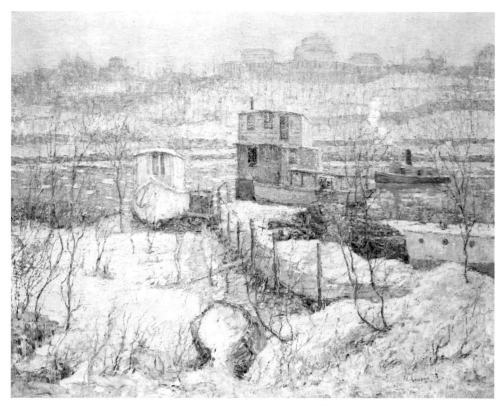

Boathouse, Winter, Harlem River
Ernest Lawson, 1916

Houseboat Mouse
Charles Sullivan (born 1933)

My house is a boat,
my boat is a house,
I live on the river
with Morris the mouse.

He moved in with me
when the weather got cold
(I think he's a he—
but I'm not sure how old).

I found him one morning
asleep in my shoe,
and let him eat breakfast
with me—wouldn't you?

He has his own plate,
and a cup, but no spoon—
he likes dinner at eight,
half a bagel at noon.

When I go to work
he keeps watch on our things,
and when I get home
how he dances and sings!

He dances on tables,
he dances on deck,
he dances on ice
and a neighboring wreck.

He sings to the river,
the sky and the snow,
and sometimes I whisper
the words that I know.

And sometimes I whisper
the words that I know,
and sometimes just listen
to him and the snow.

Morris Goes to the Art Museum

Charles Sullivan (born 1933)

Saturday was cold outdoors;
I wore my heavy coat
on top of jeans and sweaters
while I tidied up the boat.

I found some keys that I had lost,
I found a lady's locket,
then walked around the icy docks
with Morris in my pocket.

But icy docks were much too slick
and slippery for us,
so we went quickly through the park
and caught a downtown bus.

We saw some pleasant people
that a mouse would love to meet;
we talked with several children
who thought Morris was just neat!

They took us to the art museum,
much bigger than a house,
to see a special statue called
the *Geometric Mouse.*

It wasn't like a mouse to me,
more like a broken box,
but Morris sat and stared at it
while eating bits of lox.

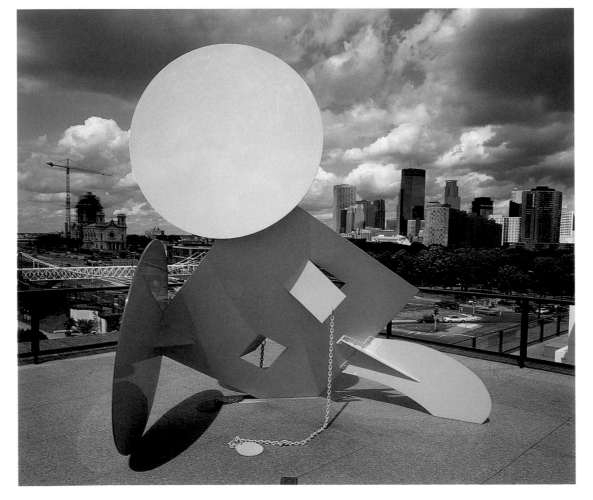

*Geometric Mouse—
Scale A*
Claes Oldenburg,
1969/1973

The statue on the rooftop sat
and stared right back at him—
or seemed to, through the shadows,
as the light was getting dim.

And that is how a modern mouse
discovered modern art,
and took a statue home with him
and kept it in his heart.

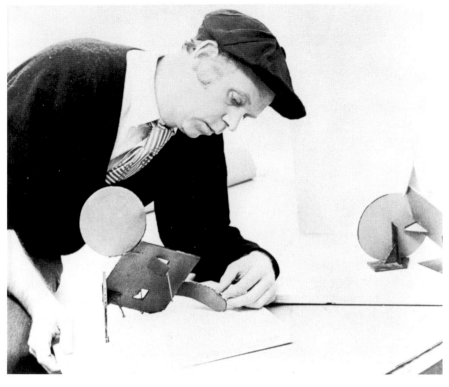

Claes Oldenburg in his New Haven, Connecticut,
studio with a model of *Geometric Mouse.*

Morris & Boris
Charles Sullivan (born 1933)

Boris is a Russian rat
who visits twice a year;
ask him the Russian word for *"cat"*
and he will disappear!

But say the Russian word for *"cheese"*
and he pops out again,
as nice and friendly as you please,
to talk of mice and men.

Tonight we sat around the lamp,
more cozy on our boat
than Eskimos in winter camp
or other folks afloat.

We shared our cheddar cheese and bread,
we made some Russian tea,
then said goodnight and went to bed
and dreamed about the sea.

My dreams were full of pirate ships
whose captains looked like Boris,
with cargoes of potato chips
that might have tempted Morris,

but Boris left and Morris stayed;
he later woke me up
with sunshine in the marmalade
and coffee in my cup.

85

The Owl and the Pussy-cat

Edward Lear (1812–1888)

The Owl and the Pussy-cat went to sea
 In a beautiful pea-green boat,
They took some honey, and plenty of money,
 Wrapped up in a five-pound note.
The Owl looked up to the stars above,
 And sang to a small guitar,
"O lovely Pussy! O Pussy, my love,
 What a beautiful Pussy you are,
 You are,
 You are!
 What a beautiful Pussy you are!"

Pussy said to the Owl, "You elegant fowl!
 How charmingly sweet you sing!
O let us be married! too long we have tarried:
 But what shall we do for a ring?"
They sailed away, for a year and a day,
 To the land where the Bong-Tree grows,
And there in a wood a Piggy-wig stood,
 With a ring at the end of his nose,
 His nose,
 His nose,
 With a ring at the end of his nose.

"Dear Pig, are you willing to sell for one shilling
 Your ring?" Said the Piggy, "I will."
So they took it away, and were married next day
 By the Turkey who lives on the hill.
They dined on mince, and slices of quince,
 Which they ate with a runcible spoon;
And hand in hand, on the edge of the sand,
 They danced by the light of the moon,
 The moon,
 The moon,
 They danced by the light of the moon.

Fog
Carl Sandburg (1878–1967)

The fog comes
on little cat feet.

It sits looking
over harbor and city
on silent haunches
and then moves on.

Boat
Costas Tsoclis, 1982

The Movement of Fish

James Dickey (born 1923)

No water is still, on top.
Without wind, even, it is full
Of a chill, superficial agitation.
It is easy to forget,
Or not to know at all

That fish do not move
By means of this rippling
Along the outside of water, or
By anything touching on air.
Where they are, it is still,

Under a wooden bridge,
Under the poised oar
Of a boat, while the rower leans
And blows his mistaken breath
To make the surface shake,

Or yells at it, or sings,
Half believing the brilliant scan
Of ripples will carry the fish away
On his voice like a buried wind.
Or it may be that a fish

Is simply lying under
The ocean-broad sun
Which comes down onto him
Like a tremendous, suffusing
Open shadow

Of gold, where nothing is,
Sinking into the water,
Becoming dark around
His body. Where he is now
Could be gold mixed

With absolute blackness.
The surface at mid-sea shivers,
But he does not feel it
Like a breath, or like anything.
Yet suddenly his frame shakes,

Convulses the whole ocean
Under the trivial, quivering
Surface, and he is
Hundreds of feet away,
Still picking up speed, still shooting

Through half-gold,
Going nowhere. Nothing sees him.
One must think of this to understand
The instinct of fear and trembling,
And, of its one movement, the depth.

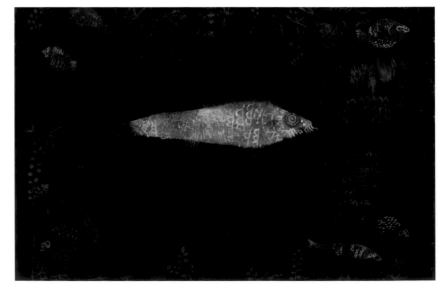

The Golden Fish
Paul Klee, 1925

To a Fish
Leigh Hunt (1784–1859)

You strange, astonished-looking, angle-faced,
　　Dreary-mouthed, gaping wretches of the sea,
　　Gulping salt-water everlastingly,
Cold-blooded, though with red your blood be graced,
And mute, though dwellers in the roaring waste;
　　And you, all shapes beside that fishy be,—
　　Some round, some flat, some long, all devilry,
Legless, unloving, infamously chaste:—

O scaly, slippery, wet, swift, staring wights,
　　What is't ye do? What life lead? eh, dull goggles?
How do ye vary your vile days and nights?
　　How pass your Sundays? Are ye still but joggles
In ceaseless wash? Still nought but gapes, and bites,
　　And drinks, and stares, diversified with boggles?

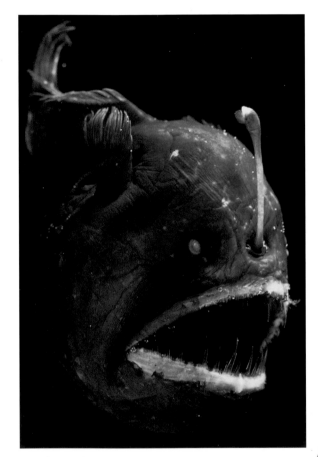

Angler Fish
Norbert Wu

A Fish Answers
Leigh Hunt (1784–1859)

Amazing monster! that, for aught I know,
　　With the first sight of thee didst make our race
　　For ever stare! O flat and shocking face,
Grimly divided from the breast below!
Thou that on dry land horribly dost go
　　With a split body and most ridiculous pace,
　　Prong after prong, disgracer of all grace,
Long-useless-finned, haired, upright, unwet, slow!

O breather of unbreathable, sword-sharp air,
　　How canst exist? How bear thyself, thou dry
And dreary sloth? What particle canst share
　　Of the only blessed life, the watery?
I sometimes see of ye an actual *pair*
Go by! linked fin by fin! most odiously.

Balloons

Sylvia Plath (1932–1963)

Since Christmas they have lived with us,
Guileless and clear,
Oval soul-animals,
Taking up half the space,
Moving and rubbing on the silk

Invisible air drifts,
Giving a shriek and pop
When attacked, then scooting to rest, barely trembling.
Yellow cathead, blue fish—
Such queer moons we live with

Instead of dead furniture!
Straw mats, white walls
And these travelling
Globes of thin air, red, green,
Delighting

The heart like wishes or free
Peacocks blessing
Old ground with a feather
Beaten in starry metals.
Your small

Brother is making
His balloon squeak like a cat.
Seeming to see
A funny pink world he might eat on the other side of it,
He bites,

Then sits
Back, fat jug
Contemplating a world clear as water,
A red
Shred in his little fist.

Harlequin's Carnival
Joan Miró, 1924–25

The Howling of Wolves

Ted Hughes (born 1930)

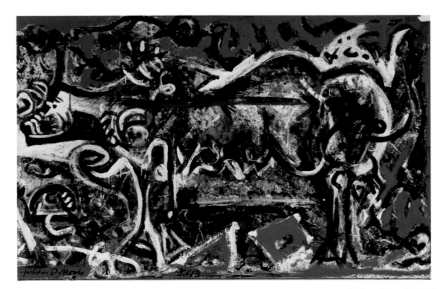

The She-Wolf
Jackson Pollock, 1943

Is without world.

What are they dragging up and out on their long leashes of
 sound
That dissolve in the mid-air silence?

Then crying of a baby, in this forest of starving silences,
Brings the wolves running.
Tuning of a viola, in this forest delicate as an owl's ear,
Brings the wolves running—brings the steel traps clashing and
 slavering,
The steel furred to keep it from cracking in the cold,
The eyes that never learn how it has come about
That they must live like this,

That they must live

Innocence crept into minerals.

The wind sweeps through and the hunched wolf shivers.
It howls you cannot say whether out of agony or joy.

The earth is under its tongue,
A dead weight of darkness, trying to see through its eyes.
The wolf is living for the earth.
But the wolf is small, it comprehends little.

It goes to and fro, trailing its haunches and whimpering horribly.
It must feed its fur.

The night snows stars and the earth creaks.

On the Grasshopper and the Cricket

John Keats (1795–1821)

The poetry of earth is never dead:
When all the birds are faint with the hot sun,
And hide in cooling trees, a voice will run
From hedge to hedge about the new-mown mead;
That is the Grasshopper's—he takes the lead
In summer luxury,—he has never done
With his delights; for when tired out with fun
He rests at ease beneath some pleasant weed.
The poetry of earth is ceasing never:
On a lone winter evening, when the frost
Has wrought a silence, from the stove there shrills
The Cricket's song, in warmth increasing ever,
And seems to one in drowsiness half lost,
The Grasshopper's among some grassy hills.

A Dog Sleeping on My Feet

James Dickey (born 1923)

Being his resting place,
I do not even tense
The muscles of a leg
Or I would seem to be changing.
Instead, I turn the page
Of the notebook, carefully not

Remembering what I have written,
For now, with my feet beneath him
Dying like embers,
The poem is beginning to move
Up through my pine-prickling legs
Out of the night wood,

Taking hold of the pen by my fingers.
Before me the fox floats lightly,
On fire with his holy scent.
All, all are running.
Marvelous is the pursuit,
Like a dazzle of nails through the ankles,

Like a twisting shout through the trees
Sent after the flying fox
Through the holes of logs, over streams
Stock-still with the pressure of moonlight.
My killed legs,
My legs of a dead thing, follow,

Quick as pins, through the forest,
And all rushes on into dark
And ends on the brightness of paper.
When my hand, which speaks in a daze
The hypnotized language of beasts,
Shall falter, and fail!

Back into the human tongue,
And the dog gets up and goes out
To wander the dawning yard,
I shall crawl to my human bed
And lie there smiling at sunrise,
With the scent of the fox

Burning my brain like an incense,
Floating out of the night wood,
Coming home to my wife and my sons
From the dream of an animal,
Assembling the self I must wake to,
Sleeping to grow back my legs.

The Fox Hunt
Winslow Homer, 1893

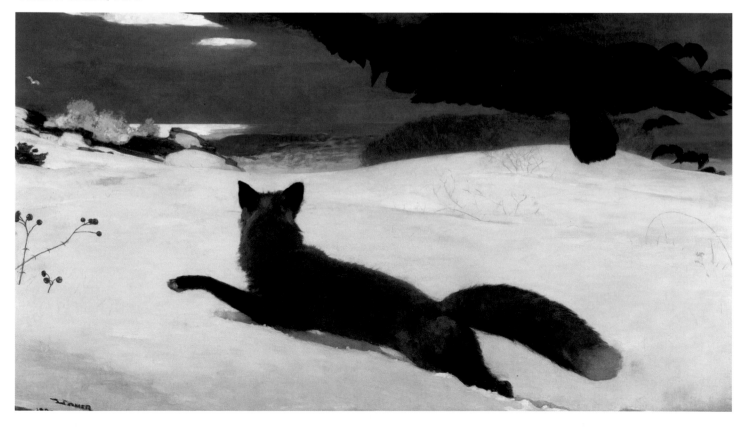

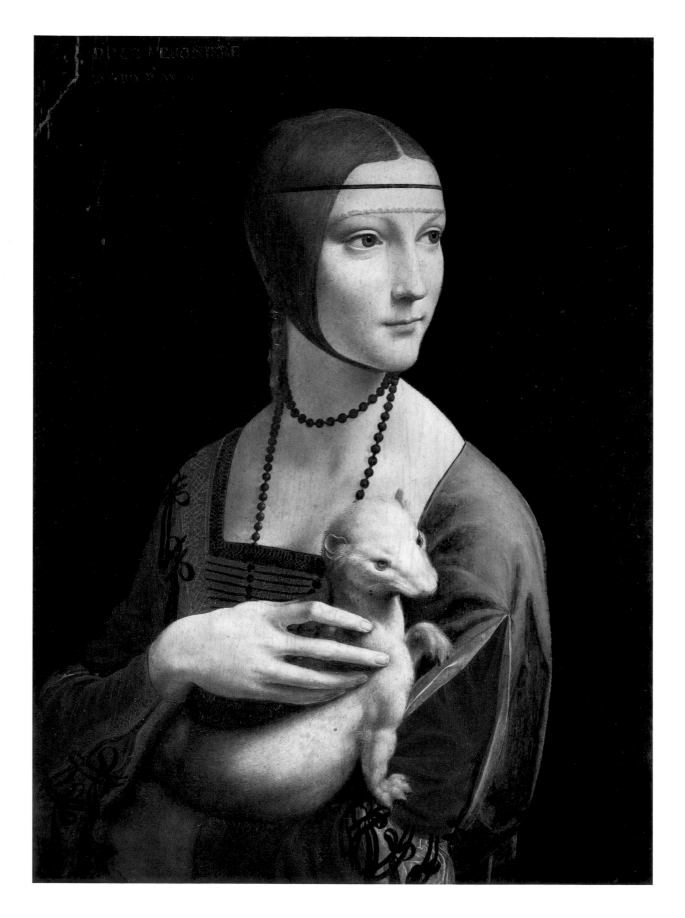

The Thought-Fox

Ted Hughes (born 1930)

I imagine this midnight moment's forest:
Something else is alive
Beside the clock's loneliness
And this blank page where my fingers move.

Through the window I see no star;
Something more near
Though deeper within darkness
Is entering the loneliness:

Cold, delicately as the dark snow
A fox's nose touches twig, leaf;
Two eyes serve a movement, that now
And again now, and now, and now

Sets neat prints into the snow
Between trees, and warily a lame
Shadow lags by stump and in hollow
Of a body that is bold to come

Across clearings, an eye,
A widening, deepening greenness,
Brilliantly, concentratedly,
Coming about its own business

Till, with a sudden sharp hot stink of fox,
It enters the dark hole of the head.
The window is starless still; the clock ticks,
The page is printed.

Small Animal

Alberta Turner (born 1919)

have I found you?
Your den is narrow, has many holes,
but earth is hollow under the spruce log
and bare by the white stone,
and grass is broken on the bank.

Snow has lain two days now, and no tracks.
You're warm or asleep or afraid.

Yet I'm no trap.
If I knew your food I'd bring it.
I'd kill for you,
whom I've never seen.

I'd put my hand deep into your den,
who are my only chance
for a wet nose in the hand
or teeth.

The Lady with an Ermine (Cecilia Gallerani)
Leonardo da Vinci, 1483–85

Caribou

Robert Penn Warren (1905–1989)

Far, far southward, the forest is white, not merely
As snow of no blemish, but whiter than ice yet sharing
The mystic and blue-tinged, tangential moonlight,
Which in unshadowed vastness breathes northward.
Such great space must once
Have been a lake, now, long ages, ice-solid.

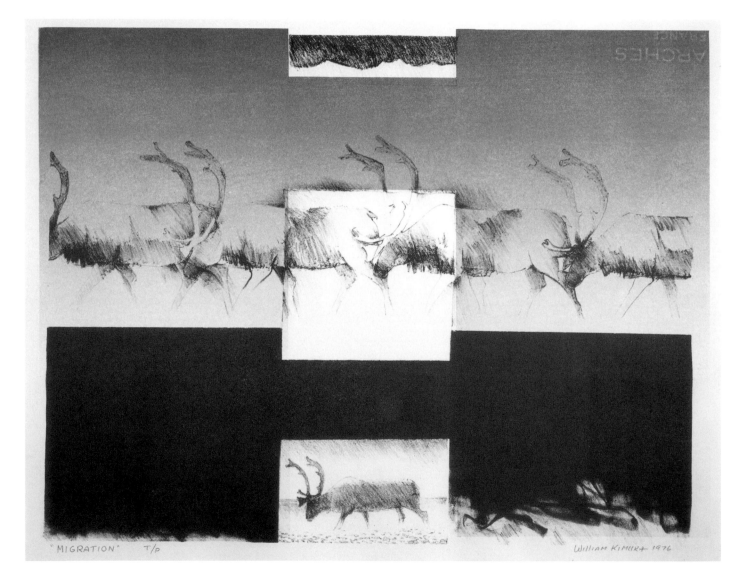

"MIGRATION" T/p William Kimura 1976

Shadows shift from the whiteness of forest, small
As they move on the verge of moon-shaven distance. They grow clear,
As binoculars find the hairline adjustment.
They seem to drift from the purity of forest.
Single, snow-dusted above, each shadow appears, each
Slowly detached from the white anonymity
Of forest, each hulk
Lurching, each lifted leg leaving a blackness as though
Of a broken snowshoe partly withdrawn. We know
That the beast's foot spreads like a snowshoe to support
That weight, that bench-kneed awkwardness.

The heads heave and sway. It must be with spittle
That jaws are ice-bearded. The shoulders
Lumber on forward, as though only the bones could, inwardly,
Guess destination. The antlers,
Blunted and awkward, are carved by some primitive craftsman.

We do not know on what errand they are bent, to
What mission committed. It is a world that
They live in, and it is their life.
They move through the world and breathe destiny.
Their destiny is as bright as crystal, as pure
As a dream of zero. Their destiny
Must resemble happiness even though
They do not know that name.

I lay the binoculars on the lap of the biologist. He
Studies distance. The co-pilot studies a map. He glances at
A compass. At mysterious dials. I drink coffee. Courteously,
The binoculars come back to me.

I have lost the spot. I find only blankness.

 But
Migration
William Kimura, 1976 They must have been going somewhere.

What Makes the Grizzlies Dance

Sandra Alcosser (born 1944)

June and finally the snowpeas
sweeten in the Mission Valley.
High behind the numinous meadows
ladybugs swarm, like huge
lacquered fans from Hong Kong,
like the serrated skirts
of blown poppies,
whole mountains turn red.
And in the blue penstemon
the grizzly bears swirl
as they gaily bat the snaps
of color against their ragged mouths.

Have you never wanted to spin like that—
delirious on hairy, leathered feet
amidst the swelling berries
as you tasted the language
of early summer, shaping
the lazy operatic vowels,
cracking the hard-shelled
consonants like speckled
ruby insects between
your silver teeth?

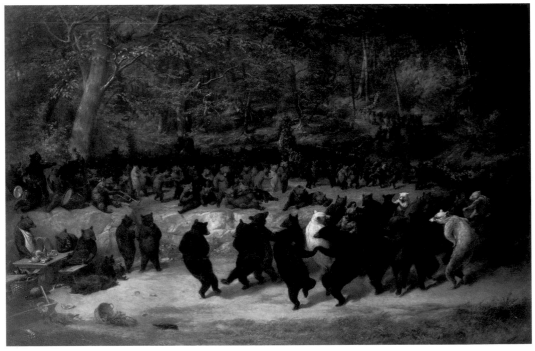

The Bear Dance
William Holbrook Beard,
about 1870s

Meeting a Bear

David Wagoner (born 1926)

If you haven't made noise enough to warn him, singing, shouting,
Or thumping sticks against trees as you walk in the woods,
Giving him time to vanish
(As he wants to) quietly sideways through the nearest thicket,
You may wind up standing face to face with a bear.
Your near future,

Even your distant future, may depend on how he feels
Looking at you, on what he makes of you
And your upright posture
Which, in his world, like a down-swayed head and humped shoulders,
Is a standing offer to fight for territory
And a mate to go with it.
Gaping and staring directly are as risky as running:
To try for dominance or moral authority
Is an empty gesture,
And taking to your heels is an invitation to a dance
Which, from your point of view, will be no circus.
He won't enjoy your smell
Or anything else about you, including your ancestors
Or the shape of your snout. If the feeling's mutual,
It's still out of balance:
He doesn't *care* what you think or calculate; your disapproval
Leaves him as cold as the opinions of salmon.
He may feel free
To act out all his own displeasures with a vengeance:
You would do well to try your meekest behavior,
Standing still
As long as you're not mauled or hugged, your eyes downcast.

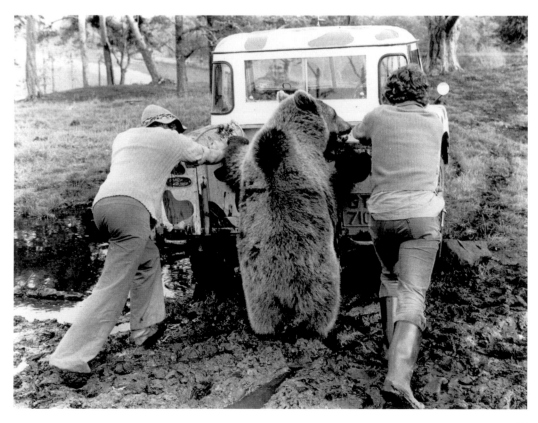

Bearing the Brunt
John Drysdale, 1965

One day, while distributing food to the animals on his daily rounds, the Chief Warden of the West Midlands Safari Park in England got his truck stuck in the mud. Unexpected help came from "Patrick," a European brown bear who lived in the park.

But if you must make a stir, do everything sidelong,
Gently and naturally,
Vaguely oblique. Withdraw without turning and start saying
Soft, monotonously, whatever comes to mind
Without special pleading:
Nothing hurt or reproachful to appeal to his better feelings.
He has none, only a harder life than yours.
There's no use singing
National anthems or battle hymns or alma maters
Or any other charming or beastly music.
Use only the dullest,
Blandest, most colorless, undemonstrative speech you can think of,
Bears, for good reason, find it embarrassing
Or at least disarming
And will forget their claws and cover their eyeteeth as an answer.
Meanwhile, move off, yielding the forest floor
As carefully as your honor.

The Bear

Galway Kinnell (born 1927)

1

In late winter
I sometimes glimpse bits of steam
coming up from
some fault in the old snow
and bend close and see it is lung-colored
and put down my nose
and know
the chilly, enduring odor of bear.

2

I take a wolf's rib and whittle
it sharp at both ends
and coil it up
and freeze it in blubber and place it out
on the fairway of the bears.

And when it has vanished
I move out on the bear tracks,
roaming in circles
until I come to the first, tentative, dark
splash on the earth.

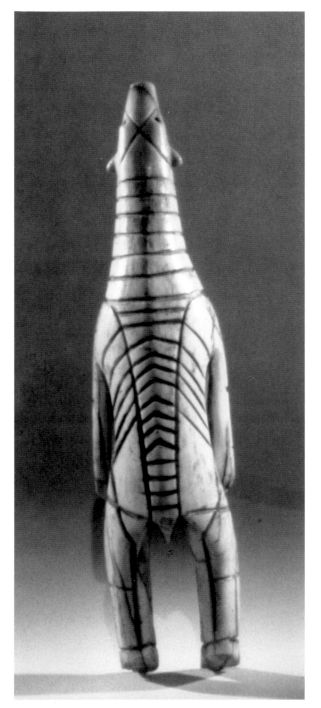

Carved Ivory Polar Bear
Dorset culture, Canada, before 500 A.D.

And I set out
running, following the splashes
of blood wandering over the world.
At the cut, gashed resting places
I stop and rest,
at the crawl-marks
where he lay out on his belly
to overpass some stretch of bauchy ice
I lie out
dragging myself forward with bear-knives in my fists.

3
On the third day I begin to starve,
at nightfall I bend down as I knew I would
at a turd sopped in blood,
and hesitate, and pick it up,
and thrust it in my mouth, and gnash it down,
and rise
and go on running.

4
On the seventh day,
living by now on bear blood alone,
I can see his upturned carcass far out ahead, a scraggled,
steamy hulk,
the heavy fur riffling in the wind.

I come up to him
and stare at the narrow-spaced, petty eyes,
the dismayed
face laid back on the shoulder, the nostrils
flared, catching
perhaps the first taint of me as he
died.

I hack
a ravine in his thigh, and eat and drink,
and tear him down his whole length
and open him and climb in
and close him up after me, against the wind,
and sleep.

5

And dream
of lumbering flatfooted
over the tundra,
stabbed twice from within,
splattering a trail behind me,
splattering it out no matter which way I lurch,
no matter which parabola of bear-transcendence,
which dance of solitude I attempt,
which gravity-clutched leap,
which trudge, which groan.

6

Until one day I totter and fall—
fall on this
stomach that has tried so hard to keep up,
to digest the blood as it leaked in,
to break up
and digest the bone itself: and now the breeze
blows over me, blows off
the hideous belches of ill-digested bear blood
and rotted stomach
and the ordinary, wretched odor of bear,

blows across
my sore, lolled tongue a song
or screech, until I think I must rise up
and dance. And I lie still.

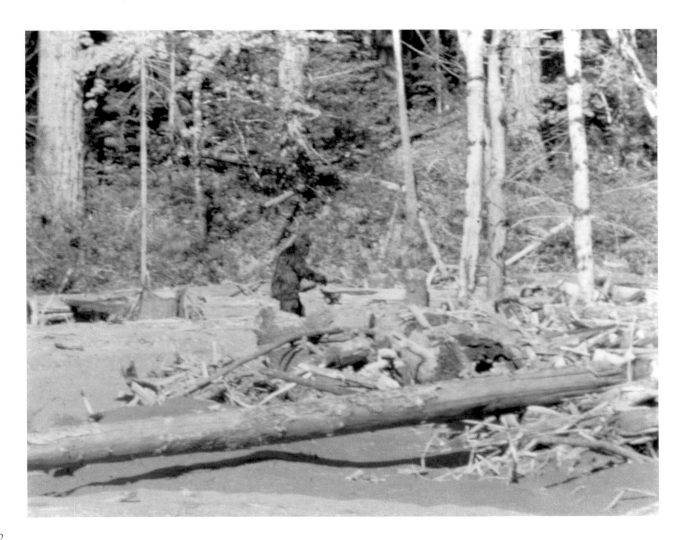

7

I awaken I think. Marshlights
reappear, geese
come trailing again up the flyway.
In her ravine under old snow the dam-bear
lies, licking
lumps of smeared fur
and drizzly eyes into shapes
with her tongue. And one
hairy-soled trudge stuck out before me,
the next groaned out,
the next,
the next,
the rest of my days I spend
wandering: wondering
what, anyway,
was that sticky infusion, that rank flavor of
blood, that
 poetry, by which I lived?

Magic Words

Inuit poem

In the very earliest time,
when both people and animals lived on earth,
a person could become an animal if he wanted to
and an animal could become a human being.
Sometimes they were people
and sometimes animals
and there was no difference.
All spoke the same language.
That was the time when words were like magic.
The human mind had mysterious powers.
A word spoken by chance
might have strange consequences.
It would suddenly come alive
and what people wanted to happen could happen.
Nobody could explain this:
That's the way it was.

Could this be Bigfoot? On the afternoon
of October 20, 1967, Roger Patterson and Bob
Gimlin were riding on horseback along the banks
of Bluff Creek in northern California when
they sighted this creature.

The Return

Thomas McGrath (1916–1989)

The trees are never the same
 twice
 the animals
 the birds or
The little river lying on its back in the sun or the sun or
The varying moon changing over the changing hills
Constant.
 It is this, still, that most I love about them.

I enter by dark or day:
 that green noise, dying
Alive and living its death, that inhuman circular singing,
May call me stranger . . .
 Or the little doors of the bark open
And I enter that other home outside the tent of my skin . . .

On such days, on such midnights, I have gone, I will go,
Past the human, past the animal, past the bird,
To the old mothers who stand with their feet in the loamy dark
And their green and gold praises playing into the sun . . .

For a little while, only. (It is a long way back.)
But at least, and if but for a moment, I have almost entered the stone.
Then fear and love call. I am cast out. Alien,
On the bridge of fur and of feather I go back to the world I have known.

Patterson was thrown from his horse, but he managed to
film the creature from a distance of about 100 feet.

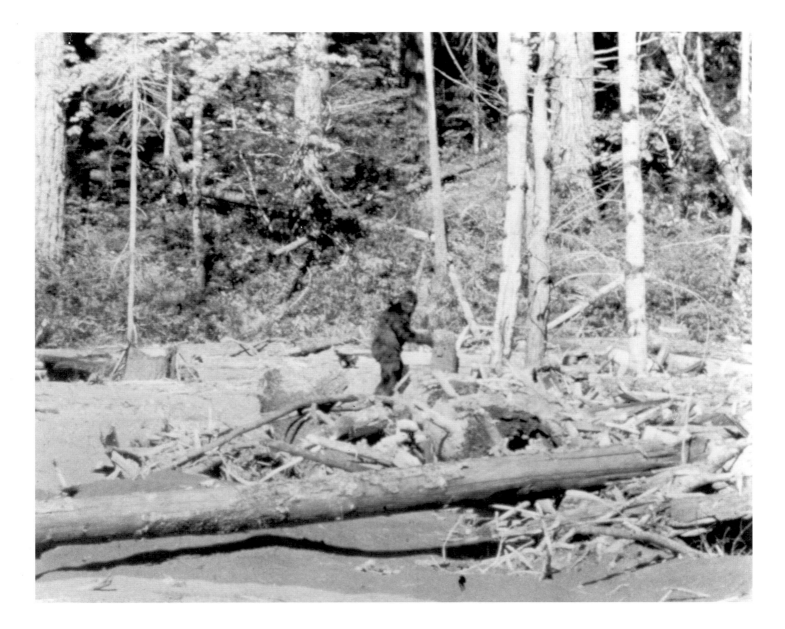

Acknowledgments

Grateful acknowledgment is made for permission to reproduce the poems, songs, and excerpts listed below by page number. All possible care has been taken to trace ownership of every selection included and to make full acknowledgment. If any errors or omissions have occured, they will be corrected in subsequent editions, provided that written notification is sent to the publisher.

Title page: "At Grass" from *The Less Deceived* by Philip Larkin. Reprinted by permission of The Marvell Press, England and Australia Page 7: James Dickey, "A Birth" from *Poems 1957–76*, copyright © 1967 by James Dickey. Wesleyan University Press by permission of University Press of New England Page 8: "The Ride" from *New and Collected Poems*, copyright © 1988 by Richard Wilbur. Reprinted by permission of Harcourt Brace & Company Page 10: "Horse and Tree" from *Grace Notes* by Rita Dove, copyright © 1989 by Rita Dove. Reprinted by permission of the author and W. W. Norton & Company, Inc. Page 11: "The Poem" from *Old and New Poems*, copyright © 1990 by Donald Hall. Reprinted by permission of Ticknor & Fields/Houghton Mifflin Co. All rights reserved Page 14: Excerpt from *The Metamorphoses of Ovid: A New Verse Translation*, English translation copyright © 1993 by Allen Mandelbaum. Reprinted by permission of Harcourt Brace & Company Page 17: "Page d'écriture" from *Paroles* by Jacques Prévert, copyright © 1949 by Editions Gallimard. Translation copyright © 1995 by Charles Sullivan Page 18: "A Lesson in Handwriting" reprinted by permission, copyright © 1961, 1989 by Alastair Reid. Originally in *The New Yorker*. All rights reserved Page 20: "The Crow" copyright © 1978 by Barbara Angell. Used by permission of the author Page 22: "New Animals" from *The Happy Man* by Donald Hall, copyright © 1986 by Donald Hall. Reprinted by permission of Random House, Inc. Page 24: "The Toomai of Elephants" from *Verse: Definitive Edition* by Rudyard Kipling. Reprinted by permission of A. P. Watt Ltd. on behalf of The National Trust for Places of Historic Interest or National Beauty Page 30: "Dragons Are Too Seldom" from *Verses From 1929 On* by Ogden Nash. Copyright © 1934 by Ogden Nash. First appeared in *The New York American*. By permission of Little, Brown and Company. Reprinted by permission of Curtis Brown Ltd. Copyright © 1934 by Ogden Nash, renewed Page 32: "Nessie" reprinted by permission of the author Page 34: "Vesper" from *Greek Poetry for Everyman*, translated from the Greek by F. L. Lucas. Reprinted by permission of David Campbell Publishers Ltd. Page 37: "Bony" from *Going for the Rain*, Harper & Row, Inc., 1976, and *Woven Stone*, University of Arizona Press, 1992. Reprinted by permission of the author

Page 38: "Alexander" from *Sophisticated Alligators* by Noël Miller. Reprinted by permission of Villard Books, a division of Random House, Inc. Page 38: "Humming-Bird" by D. H. Lawrence, from *The Complete Poems of D. H. Lawrence* by D. H. Lawrence, edited by V. de Sola Pinto & F. W. Roberts. Copyright © 1964, 1971 by Angelo Ravagli and C. M. Weekly, Executors of the Estate of Frieda Lawrence Ravagli. Reprinted by permission of Viking Penguin, a division of Penguin Books USA Inc., Laurence Pollinger Ltd., and the Estate of Frieda Lawrence Ravagli Page 39: "The Camel" by Carmen Bernos de Gasztold, from *The Creatures' Choir* by Carmen Bernos de Gasztold, decorations by Jean Primrose. Translated by Rumer Godden, translation copyright © 1965 by Rumer Godden, English text. Original copyright © 1960, 1965 by Editions du Cloitre. Reprinted by permission of Viking Penguin, a division of Penguin Books USA Inc., and Curtis Brown Page 40: "The Second Coming" reprinted with the permission of Simon & Schuster from *The Poems of W. B. Yeats: A New Edition*, edited by Richard J. Finneran. Copyright © 1924 by Macmillan Publishing Company, renewed 1952 by Bertha Georgie Yeats. Additional permission from A. P. Watt Ltd. on behalf of Michael Yeats Page 41: "wild(at our first)beasts uttered human words," copyright © 1963, 1991 by the Trustees for the E. E. Cummings Trust, from *Complete Poems: 1904–1962* by e.e.cummings, edited by George J. Firmage. Reprinted by permission of Liveright Publishing Corporation Page 42: "The Lion" from *Cautionary Verses* by Hilaire Belloc, published by Random House. Reprinted by permission of the Peters Fraser & Dunlop Group Ltd. Pages 42–43: "Ars Poetica" from *The Southern Cross* by Charles Wright, published by Vintage Books, copyright © 1981 by Charles Wright. Reprinted by permission of the author Page 44: "If They Spoke" from *Collected and New Poems 1924–1963* by Mark Van Doren. Copyright © 1963 by Mark Van Doren, copyright renewed © 1991 by Dorothy Van Doren. Reprinted by permission of Hill & Wang, a division of Farrar, Straus & Giroux, Inc. Page 47: James Dickey, "The Heaven of Animals" from *Poems 1957–76*, copyright © by James Dickey. Wesleyan University Press by permission of University Press of New England Page 48: "The Labyrinth" from *Atlas* by Jorge Luis Borges with Maria Kodama. Copyright © 1984 by Editorial Sudamericana S.A., English translation copyright © 1985 by Anthony Kerrigan. Used by permission of Dutton Signet, a division of Penguin Books USA Inc. Page 48: "An English Wood" from *Collected Poems*, published by Carcanet Press Limited. Reprinted by permission of Carcanet Press Limited, and A. P. Watt Ltd. on behalf of the Trustees of the Robert Graves Copyright Trust Page 49: "The Minotaur" from

Illustration Credits

Pages 2–3. Edgar Degas. *Chevaux de courses (Race Horses)*. c. 1895–1900. Pastel on tracing paper, laid down on cardboard, 22 x 25 1/2" (55.8 x 64.8 cm). National Gallery of Canada, Ottawa Page 7. Kasimir Malevich. *Man and Horse*. 1933. Oil on canvas, 26 1/8 x 20 1/4" (66.3 x 51.5 cm). Musée National d'Art Moderne, Centre Georges Pompidou, Paris Page 9. Marc Chagall. *The Poet Reclining*. 1915. Oil on millboard, 30 3/8 x 30 1/2" (77.2 x 77.5 cm). Tate Gallery, London. © 1996 Artists Rights Society (ARS), New York/ADAGP, Paris. Photo: Art Resource, New York Page 10. Julia Kunin. *Red Suede Saddles*. 1993. Leather, suede, 2 x 6 x 2' (61 x 180 x 61 cm). The Margulies Family Collection. © 1996 Julia Kunin. Photo: James Dee, courtesy the artist Page 11. Photo: © Skyscan Balloon Photography, Cheltenham, England Page 12. *Trojan Horse Vase*. Sixth century B.C. Ceramic, black-figure decoration, 5 1/8" (13 cm). Bibliothèque Nationale, Paris Page 13. Photo: Turkish Culture and Information Office, New York Page 14. *Fresco of centaur teaching a young hero to play the lyre*. From Herculaneum. c. 70 A.D. Museo Archeològico Nazionale, Naples. Photo: Archivi Alinari, Florence Page 15. Gjon Mili. *Picasso painting a centaur by flashlight, Vallauris, France*. 1949. Photo: Gjon Mili, *LIFE* Magazine © Time, Inc. Page 16. Eva Gonzalès, *Lyre-Bird*, detail from *Carnet Animalier*. 1879. Pencil. Collection Jacques de Mons, Paris Page 20. Alexander Calder. *Cattails and Bird*. 1968. Gouache on paper, 43 1/8 x 29 3/8" (109.5 cm x 74.6 cm). National Trust for Historic Preservation. Nelson A. Rockefeller Bequest. Pocantico Historic Area. © 1996 Artists Rights Society (ARS), New York/ADAGP, Paris Page 21. Romare Bearden. *Morning of the Rooster*, from the *Mecklenburg County* series. 1980. Collage on board, 18 x 13 3/4" (45.7 x 35 cm). Courtesy the Estate of Romare Bearden Page 23. Artist unknown, vicinity of Albany, New York. *Patterns for "Bird of Paradise" Quilt Top*. 1853–63. Cut and pinned newspaper and paper, height of elephant: 7 3/8 x 9 3/8" (18.8 x 23.8 cm). Collection of the Museum of American Folk Art, New York. Gift of the Trustees of the Museum of American Folk Art, 1979.7.2 Page 24. Mike Hollist. *What a Cheek!* 1987. Photo: © Daily Mail/Solo Syndication, London Page 25. Ceramic frog ice-cream cone © David Gilhooly. Photo © Shirley Ross Davis Page 27. Marcus Adams. *Christopher Robin Milne with Winnie-the-Pooh*. March 1928. Bromide print from original half-plate glass negative. National Portrait Gallery, London Page 28. Bernardo Martorell. *Saint George Killing the Dragon*. 1430–35. Tempera on panel, 61 1/8 x 38 5/8" (155.3 x 98 cm). The Art Institute of Chicago. Gift of Mrs. Richard E.

Danielson and Mrs. Chauncey McCormick, 1933.786. Photo © 1996, The Art Institute of Chicago. All rights reserved Page 29. Oskar Kokoschka. *Mandrill*. 1926. Oil on canvas, 50 x 40" (127 x 102 cm). Boymans-van Beuningen Museum, Rotterdam. © 1996 Artists Rights Society (ARS), New York/Pro Litteris, Zurich Page 30. Charles Negre. *Henri Le Secq and Gargoyles of Notre-Dame Cathedral, Paris*. 1851. Gelatin-silver print from original calotype negative. The Metropolitan Museum of Art, New York. Rogers Fund, 1962 (62.604.1). Photo: All rights reserved. The Metropolitan Museum of Art Page 32. Photo: R. K. Wilson, 1934 © Daily Mail/Solo Syndication, London Page 33. Bill Watterson. *Calvin and Hobbes*. © 1989 Universal Press Syndicate (seen in *Washington Post*, 12/94) Pages 34–35. Photo © 1996 Dr. Graham Hickling, Lincoln University, New Zealand Page 36. Bill Traylor. *Man and Large Dog*. 1939–42. Showcard color and pencil on paper, 28 5/8 x 22 1/2" (72.7 x 57.2 cm). Courtesy Luise Ross Gallery, New York Page 37. Alberto Giacometti. *Le Chien (Dog)*. 1951. Bronze, 18 x 39 x 6 1/8" (45.7 x 99 x 15.5 cm). Fondation Maeght Saint-Paul, France. © 1996 Artists Rights Society (ARS), New York/ADAGP, Paris. Photo © Fondation Maeght Page 38. Noël Miller. *Alexander the Alligator at Lunch Counter*. 1995. Watercolor on paper. From *Sophisticated Alligators* by Noël Miller. Copyright © 1995 by Noël Miller. Reprinted by permission of Villard Books, a division of Random House, Inc. Page 39. *Composite Camel with Groom*. Persian, second half 16th century. Gouache on paper, 8 5/8 x 6 1/4" (22 x 16.9 cm). The Metropolitan Museum of Art, New York. Gift of George D. Pratt, 1925 (25.83.6). Photo © 1996 The Metropolitan Museum of Art Page 40. Photo © Hirmer Fotoarchiv, Munich Page 41. *The Wizard of Oz* © 1939 Turner Entertainment Company. All rights reserved. Photo: Jerry Olinger's Movie Material Store, Inc., New York Page 42. Photo © 1996 Yann Arthus-Bertrand, Peter Arnold, Inc., New York Page 43. Frida Kahlo. *Self-Portrait with Monkey*. 1938. Oil on masonite, 16 x 20" (40.7 x 50.8 cm). Albright-Knox Art Gallery Buffalo, New York. Bequest of A. Conger Goodyear, 1966 Page 44. *The Sixth Day of Creation*. Italian, c. 1085. Carved ivory, 4 1/4 x 4 1/4" (10.8 cm). The Metropolitan Museum of Art, New York. Gift of J. Pierpont Morgan, 1917 (17.190.156). Photo: All rights reserved. The Metropolitan Museum of Art Page 45. Henry Moore. *Sheep Piece*. 1971–72. Bronze (edition of 3) height 14'6" (5.70 m). © The Henry Moore Foundation, Much Hadham, Hertfordshire, England. Photo © David Finn, New York Page 46. Horace Pippin. *Holy Mountain III*. 1945. Oil on canvas, 25 1/4 x 30 1/4" (64.2 x 76.8 cm).

Hirshhorn Museum and Sculpture Garden. Smithsonian Institution, Washington, D.C. Gift of Joseph H. Hirshhorn, 1966. Photo: Lee Stalsworth Page 48. *Labyrinth on a silver coin from Knossos, Crete.* c. 350–280 B.C. Athens Numismatic Museum, Greece. Photo: Ministry of Culture/Archaeological Receipts Fund (TAP Services), Athens Page 49. *Theseus Killing the Minotaur.* c. 480 B.C. Ceramic vase, red-figure decoration, height 13" (32 cm). The British Museum, London Page 50. From Dougal Dixon, *The New Dinosaurs,* © copyright 1988. Reproduced courtesy Eddison Sadd Editions Limited, London Page 51. John James Audubon. *Soft-Haired Squirrel.* c. 1845. Watercolor on paper, 11 1/4 x 16" (28.5 x 45.2 cm). Wadsworth Atheneum, Hartford. Gift of Henry Schnakenberg Page 52. René Magritte. *Le Bain Cristal (The Glass Bath).* 1946. Gouache, 19 5/8 x 13 3/4" (50 x 35 cm). Private collection. © 1996 Succession René Magritte/Artists Rights Society (ARS), New York. Photo: Art Resource, New York Page 53. Inge Morath. *New York City, 1957.* © 1957 Inge Morath, Magnum Photos, Inc., New York Page 54. Andy Warhol. *Endangered Species: Black Rhinoceros.* 1983. One from portfolio of ten screenprints printed on Lenox Museum Board, 38 x 38" (96.5 x 96.5 cm). © 1996 The Andy Warhol Foundation for the Visual Arts, Inc./Artists Rights Society (ARS), New York. Courtesy Ronald Feldman Fine Arts, New York Page 55. Photo © Fritz Palking, Peter Arnold, Inc., New York Page 57 above. Barry Flanagan. *Nijinski Hare.* 1989. Bronze (edition of 7), 94 1/2 x 45 1/4 x 29 1/2" (240 x 115 x 75 cm). © Barry Flanagan, courtesy Waddington Galleries, London. Photo © Shirley Ross Davis Page 57 below. Louise Bourgeois. *Spider.* 1994. Steel wall relief, 50 x 46 x 12 1/4" (127 x 116.8 x 31.1 cm). Courtesy Robert Miller Gallery, New York. © Louise Bourgeois/Licensed by VAGA, New York, N.Y. Photo: Allen Finkelman Page 59. Winslow Homer. *Deer Drinking.* 1892. Watercolor, 14 x 20" (35.6 x 50.8 cm). Yale University Art Gallery, New Haven. The Robert W. Carle, B.A. 1897, Fund Page 60. Winslow Homer. *The Unruly Calf.* c. 1875. Pencil with Chinese white on paper, 4 4/8 x 8 13/16" (11.7 x 22.3 cm). The Brooklyn Museum. Museum Collection Fund (24.241) Page 61. Clark Coe. *Man on a Hog.* c. 1890. Carved, assembled, and painted wood, tinned iron, and textile remnants, 37 x 38 x 21 3/8" (94 x 96.5 x 54.3 cm). National Museum of American Art. Smithsonian Institution, Washington, D.C. Gift of Herbert Waide Hemphill, Jr., and Museum Purchase made possible by Ralph Cross Johnson. Photo: Art Resource, New York Page 63. Salvador Dalí. *Lobster Telephone.* 1936. Mixed media, including steel, plaster, rubber, resin, and paper, 7 x 13 x 7" (17.8 x 33 x 17.8 cm). Tate Gallery, London. © 1996 Demart Pro Arte, Geneva/Artists Rights Society (ARS) New York. Photo: Art Resource, New York Page 64. Edwin Landseer. *Study of a Young Hippopotamus.* 1850. Pen and brown wash, 6 1/2 x 8 5/8" (16.5 x 21.9 cm). Royal Library, Windsor. Reproduced by gracious permission of Her Majesty Queen Elizabeth II. Photo © Her Majesty Queen

Elizabeth II Page 65. Henry Moore. *Owl.* 1966. Bronze (edition of 5), height 7 7/8" (20 cm). The Henry Moore Foundation Hoglands, England. © The Henry Moore Foundation Page 66. Claude Monet. *La Pie (The Magpie).* 1868–69. Oil on canvas, 35 x 51 1/8" (89 x 130 cm). Musée d'Orsay, Paris. © 1996 Artists Rights Society (ARS), New York/SPADEM, Paris. Photo: Réunion des Musées Nationaux, Paris Page 68. M. E. Warren. *Maryland, Eastern Shore.* 1982. Photo © M. E. Warren Page 70. Pablo Picasso. *A Child with a Dove.* 1901. Oil on canvas, 36 1/4 x 28 3/4" (92 x 73 cm). Private collection on loan to The National Gallery, London. © 1996 Succession Picasso/Artists Rights Society (ARS), New York Page 71. Berthe Morisot. *The Cage.* 1885. Oil on canvas, 19 7/8 x 15" (55 x 38.1 cm). The National Museum of Women in the Arts, Washington, D.C. Gift of Wallace and Wilhelmina Holladay Page 73. Henri Cartier-Bresson. *Henri Matisse in His Studio with Doves, Vence, France.* 1946. © 1946 Henri Cartier-Bresson, Magnum Photos, Inc., New York Page 74. Mary Cassatt. *Summertime.* 1894. Oil on canvas, 28 7/8 x 39 3/8" (73.4 x 100 cm). The Armand Hammer Collection. UCLA at the Armand Hammer Museum of Art and Cultural Center, Los Angeles, California. © 1996 Artists Rights Society (ARS), New York/ADAGP, Paris Page 75. Winslow Homer. *Girls with Lobster.* 1873. Watercolor, 9 1/2 x 13" (24.3 x 33 cm). Cleveland Museum of Art. Purchase from the J. H. Wade Fund, 43.660. Photo © 1995 Cleveland Museum of Art Page 76. Alexander Calder. *The Cow.* 1930. Bronze, 6 1/8 x 8 1/8 x 3 1/2" (15.5 x 20.6 x 8.9 cm). In the collection of Olga Hirshhorn. Photo: The Corcoran Gallery of Art, Washington, D.C. Page 77. Mark Tansey. *The Innocent Eye Test.* 1981. Oil on canvas, 78 x 120" (198.1 x 304.8 cm). The Metropolitan Museum of Art, New York. Promised gift of Charles Cowles, in honor of William S. Lieberman, 1988 (1988.183). © Mark Tansey, courtesy Curt Marcus Gallery, New York. Photo: All rights reserved. The Metropolitan Museum of Art Page 78. John Singer Sargent. *Young Boy on the Beach, Sketch for Oyster Gatherers of Cancale.* 1877. Oil on canvas, 17 1/4 x 10 1/4" (43.8 x 26.0 cm). Daniel J. Terra Collection, 38.1980. Photo © 1996, courtesy Terra Museum of American Art, Chicago Page 80. Joan Baron. *Cat Couples (Picasso and Putz in front of their portrait by Mimi Vang Olsen).* 1985. Photo © Joan Baron, New York Page 81. Cecilia Beaux. *Man with the Cat (Henry Sturgis Drinker).* 1898. Oil on canvas, 48 x 34 5/8" (122 x 88 cm). National Museum of American Art. Smithsonian Institution, Washington, D.C. Photo: Art Resource, New York Page 82. Ogawa Haritsu (Ritsuo). *Writing Box with Mice Chewing a Fan.* Japanese, 17th–18th century. Lacquer on wood, 10 1/8 x 8 1/8 x 1 3/4" (25.7 x 20.6 x 4.5 cm). The Metropolitan Museum of Art, New York. Bequest of Mrs. H. O. Havemeyer, 1929. The H. O. Havemeyer Collection (29.100.703). Photo: All rights reserved. The Metropolitan Museum of Art Page 83. Ernest Lawson. *Boathouse, Winter, Harlem River.* 1916. Oil on canvas, 40 1/2 x 50 1/8" (102.87 x 32 cm). In the Collection of the Corcoran Gallery

Index to Artists

Index to Poets